From Handprints *to* Hypotheses

Using the Project Approach with Toddlers and Twos

TODD WANERMAN

Foreword by Carolyn Pope Edwards

Redleaf Press®
www.redleafpress.org
800-423-8309

Published by Redleaf Press
10 Yorkton Court
St. Paul, MN 55117
www.redleafpress.org

First edition 2013

Cover design by Jim Handrigan

Cover photograph © Natalia Ulrikh/Veer

Author photograph by Megan London

Interior design by Percolator

Typeset in ITC Stone Informal

Interior photographs by Todd Wanerman, Megan London, Lisa Treadway,
 and Lindsey Freedman

Illustration on page 33 by Sofia Dillingham

Printed in the United States of America

19 18 17 16 15 14 13 12 1 2 3 4 5 6 7 8

Excerpt from *Abiyoyo* by Pete Seeger (New York: Simon and Schuster, 1986) is reprinted with
the permission of Simon & Schuster Books for Young Readers, an imprint of Simon & Schuster
Children's Publishing Divison. Text © 1963, 1964, 1986 by Fall River Music, Inc.

Library of Congress Cataloging-in-Publication Data
Wanerman, Todd.
 From handprints to hypotheses : using the project approach with toddlers and twos /
Todd Wanerman.
 p. cm.
 Summary: "From Handprints to Hypotheses focuses on using the project approach—
a teaching strategy that enables you to guide children through in-depth studies of real world
topics—to scaffold very young children's early learning. It provides information on creating
sensory-based experiences—developmentally appropriate for toddlers and twos—that bring
new perspectives and activities into the classroom" — Provided by publisher.
 Includes bibliographical references and index.
 ISBN 978-1-60554-123-5 (pbk.)
 ISBN 978-1-60554-246-1 (e-book)
 1. Project method in teaching. 2. Early childhood education—Curricula. I. Title.
LB1139.35.P8W36 2013
371.3'6—dc23
 2012032258

Printed on acid-free paper

To my own children, and all the artists in my family

To the community of artists—children and families—
I am privileged to support

To the family of artists, young and old, around the world

Contents

Foreword

BY CAROLYN POPE EDWARDS

From the very beginning, curiosity and learning refuse simple and isolated things: they love to find the dimensions and relations of complex situations.

—Loris Malaguzzi, *The Hundred Languages of Children: Narrative of the Possible*

In an earlier article, I suggested that projects combine two things that toddlers love dearly: play and investigation. Now, after reading Todd Wanerman's book, I would add *expression* to that set of what is nearest and dearest to toddlers' hearts. *From Handprints to Hypotheses: Using the Project Approach with Toddlers and Twos* is about project-based arts education. The book explains the aims and methods of such an approach and, better yet, takes us inside to see how it might unfold from day to day. It illustrates one North American educator's personal interpretation of a Reggio-inspired pedagogy for toddlers with abundant detail and helpful images. Thus, the book suggests one way to implement a project-based arts education focusing on children's emerging expressive capacities—taking children on a developmental journey from their earliest explorations of materials, where concepts are organized around their perceptions and actions, to long-term inquiries that spring from an idea or question about the materials or about what can be understood through work with materials.

The book and all the stories and vignettes presented also make a strong case for why it even makes sense to undertake "projects" with this age group—that is, why it makes sense to engage them in group learning that requires organizing, negotiating, and collaborating and that calls on them to look forward and backward as they work together. All too often, the curriculum for children this age (twelve to thirty-six months) involves simple activities and experiences that come and go with no deep or necessary connection from one to the next. Perhaps because children under three are so obviously immersed in the immediate moment and in the process rather than the product of their activity, teachers and providers may think that they should develop their curriculum without planning emergently

or elaborating threads of connection between different learning encounters. Yet such a viewpoint clearly underestimates children's search for meaning and their drive to discover the dimensions and relations of complex situations, as Malaguzzi describes in the quotation on the previous page.

Who exactly are "toddlers and twos" anyway? Are they babies? Or are they preschoolers? In fact, there is great professional uncertainty about whether toddlerhood is a distinct phase of the life cycle, and this uncertainty bears on why teachers may disagree on how best to support their learning. From a development standpoint, the period bridging infancy and early childhood (between about twelve and thirty-six months of age) is seen as a time of rapid growth and change, yet no consensus exists among the experts about when toddlerhood begins and ends or even about whether it is a full-fledged phase, much less a stage, of the life cycle. Psychologists define a *stage* as a distinct time of development bounded by fundamental reorganizations in cognitive and social-emotional capacities and characterized by a unique pattern of developmental issues, tasks, and achievements. Toddlers and twos are children making their way between infancy and early childhood, but they look more like a mix of both stages than something categorically distinct from them. Thus, some child development textbook authors divide their material on childhood into three major periods: infancy, early childhood, and middle childhood. In contrast, others treat infancy and toddlerhood as two separate periods prior to early childhood. When authors blend toddlerhood into infancy, they tend to place the boundary age marking the transition to early childhood at twenty-four months. But when they treat toddlerhood as a separate period, they tend to move the boundary age forward to the middle or end of the third year, at thirty or thirty-six months. Whichever approach they take, psychologists tend to describe certain kinds of tasks as salient to children in their second and third years of life: achieving autonomy and independence, forming a self-concept, mastering impulses and regulating emotions, and becoming prosocial and oriented to rules and standards of the community.

Todd Wanerman, thankfully, does not bother with this academic controversy but shows us through his examples and his sequence of chapters that he intimately understands the highly individualized ways that children face their life tasks. For example, children are becoming self-reliant and concentrated in their play, or they are overcoming fears of messy materials or dangerous-seeming stimuli. Toddlers also grow and change in their approach to materials from age one to age three, in a way captured by Wanerman's shorthand phrase "from handprints to hypotheses." I found it very helpful to think about how projects focused on younger toddlers involve more open-ended sensory exploration of how their hands and bodies interact with the world, while projects focused on older toddlers involve more cognitive abstraction and purpose to probe or represent concepts

through a finished product. I also appreciated the many, many concrete examples of exactly how a teacher or provider might work with children to explore color, texture, and tools with paint, glue, paper, and fragments collected from the world of nature or the household.

In sum, the main goal of this book is to share the concrete strategies the author has discovered for how teachers can help children flourish in their capacities to express, represent, and communicate. He grounds all of his ideas in relationship-based education—that is, the perspective that children learn in the context of close and caring relationships with peers and adults. I have seen many outstanding toddler teachers in my time, and I know they readily invite children to explore materials, but I believe this new book will provide teachers with welcome information on enriching what and how materials are offered to toddlers and explaining why teachers should document and plan. The book is less about the documentation process itself than other resources I could also recommend, and less about the detailed analysis and interpretation of the evidence of children's learning, than it is about teaching strategies in early arts education. Teachers and providers do need to know more about these skills—for instance, how to select and combine materials, introduce repetition and variation, break things into small steps, plan sequences, and unpack symbols. As more and more children enter group care at younger ages, we educators need to expand our repertoire of ways to extend children's expressive creativity and feed their budding desires to make a mark on their environment and establish a first sense of identity and belonging.

For Further Reading

Edwards, Carolyn Pope, Lella Gandini, and George Forman, eds. 2012. *The Hundred Languages of Children: The Reggio Emilia Experience in Transformation.* 3rd ed. Santa Barbara, CA: Praeger.

Edwards, Carolyn Pope, and Wen-Li Liu. 2002. "Parenting Toddlers." In the second edition of *Children and Parenting*, vol. 1 of *Handbook of Parenting*, edited by Marc H. Bornstein, 45–72. Hillsdale, NJ: Lawrence Erlbaum.

Edwards, Carolyn Pope, and Carlina Rinaldi, eds. 2009. *The Diary of Laura: Perspectives on a Reggio Emilia Diary.* St. Paul, MN: Redleaf Press.

Raikes, Helen H., and Carolyn Pope Edwards. 2009. *Extending the Dance in Infant and Toddler Caregiving: Enhancing Attachment and Relationships.* Baltimore, MD: Paul H. Brookes.

Acknowledgments

This is the first book I wrote on my own. It would not have been possible without the collaborators, supporters, and friends listed here:

My editor Danny Miller understood and liked the book from the start. He trained a clear and honest eye on the first draft without letting his enthusiasm wane. It was as fun as it was easy working with him.

I am honored and thrilled to have Carolyn Pope Edwards's foreword and am sincerely thankful for her participation.

David Heath, Kyra Ostendorf, Jim Handrigan, Carla Valadez, and all the other folks at Redleaf Press are, to a person, truly devoted to creating growth in the field of early childhood education—not to mention being flexible, relaxed, and incredibly good at their jobs. I am inspired to be part of their stable of authors.

The staff and families at The Little School form a uniquely supportive and creative community. They have shown excitement for the book from the idea stage. Creativity is one of the most visible values of our program—from how we value children's thinking and work to how we work together as a group. This book is a product of that community. My very sincere thanks to the families who consented to include images of their children at work. These photographs made the book. Special thanks to my current coteacher, Sarita Escobar, for creative inspiration, rooting me on, and enduring my divided attention!

I owe a priceless debt to the teachers in the toddler classes at The Little School: Tim Treadway, Lisa Treadway, Megan London, and Lindsey Freedman. They embraced and encouraged this project from the start, gave me constant support and advice, and opened their classrooms to me with enthusiasm and patience. Their collaboration with me exemplifies the integrated approach to children and their surrounding community that I hope this book will present. Thanks to them, I can *show* you these projects. I have worked with Tim and Lisa for over twenty years. They taught me much of what I know about teaching, and I'd like to think I had a beneficial effect on theirs as well.

I must reserve special thanks for Megan London, my coteacher of six years in a toddler classroom. Megan's insight into very young children, her talent for partnering with them in work and play, and her creative and energetic stance

toward curriculum helped develop two-thirds of these projects. I am happy you will get to see her work in this book.

Special thanks also go to Leslie Roffman and Cassie Britton, my partners in my first publishing experience two years ago. I would never have had the courage to try this on my own if we hadn't figured it out together! As director and program director at The Little School, their ideas are woven directly into the fabric of this book.

My thanks to fellow faculty members in the early childhood education department at San Francisco State University, especially Debra Luna, Barbara Henderson, Daniel Meier, Mina Kim, Phonita Yuen, Laura Miles-Banta, Kimberly Hughes, Darcy Campbell, and Nkechi Nwankwo.

Love and thanks to friends and family who provided ideas, pep talks, food, drinks, and company: Leon Wanerman, Paddy Goodhart, Megan Hinchliffe, Zev Wanerman, Arlo Wanerman, Laura Phipps, Guy Phipps, Brian Wanerman, Brad Goodhart, Nancy Rosenblum, Sarah Maxwell, Leah Maxwell, Brian Kreischer, Gage Kenady, Mark Pothier, Kee Fricke, Ray Wilcox, Brie McFarland, Jennifer DiGioia, Hui Li, Jae Paik, Taoran Zheng, Jiryu Thongnamsap, Janice Bressler, Tamara Scheulov, and Samantha Grey.

Finally, my deepest acknowledgment must go to Dr. Lilian Katz and Sylvia Chard, authors of *Engaging Children's Minds: The Project Approach*; to Loris Malaguzzi, Lella Gandini, Carlina Rinaldi, Sergio Spaggiari, and all the Italian educators who developed unique inquiry-based early childhood pedagogy; and to Carolyn Edwards, George Forman, and the American educators who adapted Italian approaches for our culture and for toddlers.

My sincere, paint-splattered gratitude to you all!

Introduction

I am the kind of person who always likes to have a project. There is rarely a moment when I am not writing, gardening, cooking, organizing a social event, or playing music. People like me are sometimes called productive.

For the most part, our culture approves of people who seize the day and accomplish a lot—it is part of the American character. On the other hand, I know firsthand that people who are never idle may seem hyperdriven and can get in over their heads. In fact, one of my best friends recently asked me, "Why are you doing all this stuff?"

There is a strong temperamental strain of high activity in my family. Though my mother is now in her seventies, she works a demanding job; grows vegetables and fruit, including olives; keeps chickens; belongs to a quilting group; and on and on. And I can still remember her nagging *her* mother not to constantly sweep up around our house on a Sunday.

The truth is that constantly busy people can have problems with organization or follow-through when they take on too much or don't know how to manage or finish what they start. There can be a deep well of discomfort at the heart of their activity. Society has even discovered—or created, depending on whom you ask—a disorder to describe certain people like this: attention deficit disorder (ADD) or attention deficit hyperactivity disorder (ADHD). Others can simply hyperfocus or get too preoccupied doing something over and over again until it resembles exactly what they have in mind. There's a name for people like this too: perfectionists.

Although I have been "diagnosed" as a perfectionist, what I like most is the *process* of creating—the imagining and discussing and experimenting and mucking around—rather than the perfect end result. Thanks to my years of learning from children, I prize improvisation, abrupt one-hundred-eighty-degree changes of direction, accidents, surprises, and even problems that come up in the doing. The most productive people still need to explore the steps and questions along the way toward a goal. Productivity, regardless of individual style, is a matter of process and product, determination and flexibility, curiosity and certainty.

Everybody has a productive mind and body, but people are busy in different ways. Society values creativity, perseverance, originality, vision, expression,

organization, patience, curiosity, imagination, and synthesis. Surely everyone's personality and preferences reflect some combination of these traits.

Society tends to recognize and reward the most accomplished, creative, and organized types—those who might be described as "type A" or "alpha." At the bottom of the social scale might be the very busy and inventive little boy in my class whose contribution to the year-end gift book for me was a mere scribbled line and the dictated words, "I just don't like projects."

We have become very aware of how important it is for early childhood settings to support children's initiative and the unique ways in which they express it. We understand that everyone has ideas they want to put in motion—from the most naturally industrious or productive individuals to those who seem tentative, slow to warm, resistant, stymied, or disorganized. In our efforts to support all children and a wide variety of learning styles, we as teachers are learning to look at the range of children's strengths and preferences.

Initiative, productivity, and confidence are universal human characteristics that each person can foster and cultivate in unique ways. Educators are beginning to understand productivity as a matter of individuals and groups finding their best fit as learners who support one another.

At the same time, early childhood educators have focused on the importance of creativity in children's lives. This is part of our increasing sensitivity to self-expression and open-ended exploration in the preschool years. As mindful teachers, we want to help children trust and celebrate their own ideas and impulses by honoring and celebrating those ideas and impulses ourselves. The emphasis on creativity, like that on play, has been informed by a growing discomfort with the push to extend our current, objective-based, standardized model of elementary education into the preschool years. In addition, we see children's imaginations dictated and limited by commercial media.

This book is about helping different children nurture their own unique ways of exploring and learning. It focuses on a narrow developmental period— toddlerhood—and on one specific but fundamental aspect of the curriculum: art. In doing so, I hope to offer not only a model for supporting toddlers' transitions from sensory exploration to organized projects but also a way of thinking about and supporting the different intellectual and creative qualities of children. In other words, this book is about thinking more creatively about creativity and about examining underlying cultural expectations and values related to creativity as well.

The ideas and activities presented here provide examples of how we can help young children learn to be learners and learn to become themselves. I have been lucky enough to teach toddlers for the last twenty years at The Little School in San Francisco, an institution where families and faculty have a passion for partnering

with children in creative pursuits. But more than that, The Little School has developed its own unique balance of presenting a flexible, open-ended, art- and play-based curriculum that guides children on their journey to becoming competent students, able to make abstract observations, generate questions or goals, and organize a process of inquiry. There is much learning happening at all ages at The Little School—from digging in the mud to creating an original ballet.

As with any preschool program, The Little School takes care to promote math, reading, writing, thinking strategies, and motor skills to prepare young children for elementary school. But as this book illustrates, it also aims to support the deeper development that allows children to draw abstract learning from real projects. The school tries to help children fuse what Erik Erikson (1963) described as a child's emerging self-concept with what Lilian Katz and Sylvia Chard (2000, 7) call "dispositions to observe and investigate."

The greatest gift any early childhood program can offer is a disposition and a tool kit for pursuing learning that is connected to one's growing sense of self as competent and unique. It is in this context, then, that this book will consider creativity as a means of helping children learn about learning, about themselves, and about themselves as learners. It will focus on what, for very young children, can seem the least brainy or academic of pursuits—sensory-based art projects—and sift out how explorations of texture, color, construction, structure, and sequences can act as what Vygotsky (1978) called a "scaffold" to another mode of thinking and exploring, in particular, abstract, evolving, collaborative projects.

This book will look closely at how art projects, like imaginative games, building projects, or science experiments, can act as an umbrella under which many different types of learners and explorers can inspire and extend each other's growth and development.

WAYS TO USE THIS BOOK

My aim with this book is to fill a gap in the general approach to toddler curricula. I want to balance developmental and curriculum theories with accounts of real practice to help you provide inspiring and enriching art experiences for very young children. I want this book to be general enough to help you further your own approaches to your curriculum, but specific enough to give you new projects and ideas to use right away. You can use this book in a number of ways:

- You can reproduce the actual projects—and have something new to do in class tomorrow!

- You can use the projects as a template for your own art explorations.
- You can use the goals and perspectives of these projects as a model for your art curriculum.
- You can adapt this broad view of toddlers throughout your curriculum and teaching.
- You can create your own teacher research.

Welcome to the world of toddler projects!

Toddlers and Projects: Some Definitions

WHAT IS A PROJECT?

In early childhood programs we use the word *project* so commonly that we take it for granted. In particular, we use the term *art project* to describe a wide range of creative experiences. We could be referring to something as simple as finger-painting or as complicated as a simulated pirate ship. We could mean something that will hang on the wall, hold plants, appear in a performance once or twice, or simply happen in some way and leave nothing behind. But *art project* is an educational term and a cultural concept we pass on to children reflexively, in no small part because we remember doing art projects during our own childhoods.

Our working model of a project typically contains some or all of the following elements:

- It has a start and a finish.
- It has more than one step.
- It involves planning.
- It involves a goal or a vision of an outcome.
- It involves tools.

Defining *Project*

The word *project* has many meanings of interest to designers of early childhood curricula: to "project" outward, as in asserting your idea or speaking up loudly; to get your idea or needs across; to project images on a large surface where all can see; to see your feelings in others, or vice versa. A *project* is a common undertaking that requires organizing, negotiating, and collaborating. To work on a project means to look forward, to predict outcomes, to set something in motion and to shape it as it evolves and changes, and, perhaps most of all, to express your inner self in visible ways.

- It involves putting elements together into something larger.

- It requires observation and adjustment between the start and the finish.

- It requires negotiation, communication, and collaboration.

- It requires certain skills, knowledge, and capacities.

- It increases or improves certain skills, knowledge, and capacities.

- In can involve both work and play.

- It often results in some kind of culminating product or event that is celebrated and/or displayed.

Early childhood educators, by the nature of their close partnership with their students, are naturally attuned to projects. It is the day-to-day business of our work to get down on the floor or sit at child-sized tables and help children break their big ideas into steps, organize a plan of action, collect the necessary tools and materials, and move forward. If we are lucky, we are able to revisit the projects we create with our students over time and help them pursue their initiative to new ends.

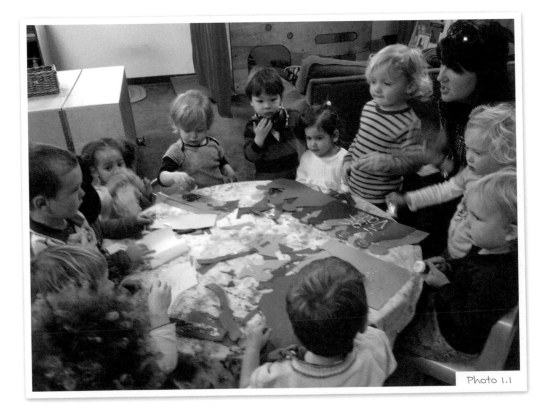

Photo 1.1

Over the last twenty years, the field of early childhood education has seen a growing emphasis on project work, or what has become known as *project-based education*. Drawing on Dewey's (1916), Montessori's (1967), and Piaget's (1971a) ideas that children "construct" knowledge, a generation of early childhood educators has focused on projects not just as vehicles for learning but as a curriculum model and learning outcome (Malaguzzi 1998; Katz and Chard 2000). The teacher's role in project-based learning is to facilitate children's emerging skills of inquiry and investigation.

The benefits of project work include the following:

- It is built on children's initiative.

- It focuses on fostering children's curiosity and learning habits as opposed to focusing on specific content or academic skills.

- It promotes a stance and approach toward learning that is sequential, observation-based, responsive, and systematic.

- It accommodates different learning styles and strengths, and it teaches children with different learning styles how to work together.

- It encourages collaboration and negotiation.

- It encourages abstract reasoning, critical thinking, and initiative.

Two curriculum models in particular have brought project-based education to the forefront of our field. The state-subsidized child care centers and preschools in Italy, especially those in the northern town of Reggio Emilia, first came to attention in the United States in the 1990s with their traveling exhibit, *The 100 Languages of Children*. It is not a coincidence that our introduction to the Reggio Emilia approach was a collection of children's artwork. American early childhood educators have grappled with the aims and details of Reggio Emilia since then, but no one has missed the power of their methods in helping children use art to make sense of themselves and the world and in putting children's creative capacities at the center of the curriculum.

The Project Approach, developed by Sylvia Chard and Lilian Katz, reflected an awareness of America's preoccupation with measurable outcomes and standards in education. The approach argues that play-based preschool education is important not because it is a prelude to education but because it creates a lab for learning how to learn. As Katz and Chard (2000, 38) put it, "Project work is the part of early childhood curriculum that provides contexts for children to strengthen their intellectual dispositions as well as to apply their developing academic skills and to strengthen the dispositions to use them."

Teachers have noted that facilitating a high level of collaboration and creativity in early childhood environments can be very complicated. In particular, teachers of toddlers and young preschoolers noticed a conspicuous absence of students their age in the canon of project-based curriculum. In fact, in their book, Katz and Chard (2000, 17) are frank: "As we use the term, we imply a level of initiative and responsibility on the part of the children that would be difficult with most groups of children under three years old."

They were not alone in this view. Toddlers, in the eyes of many twentieth-century developmental theorists, were still largely waiting for the ability to hypothesize, not to mention negotiate, collaborate, sequence, and categorize. Although there were a few important exceptions (Edwards and LeeKeenan 1992; Musatti and Mayer 2001), most of the dialogue about and development of project-based curriculum centered around four- and five-year-olds.

WHO ARE TODDLERS?

The definition and ideas of infancy, toddlerhood, and childhood have been the subject of much discussion, debate, and revision in the last two decades. The trend in recent years has been toward separating stages of early childhood into smaller substages, each with unique attributes and needs (Mangione, Lally, and Singer 1990):

- infants: birth to eight months
- mobile infants: eight to eighteen months
- toddlers: eighteen to thirty-six months
- preschoolers: thirty-six to sixty months

This book focuses on toddlerhood and the months before and after—from the beginnings of mobility and language, around ten to fourteen months, to the early preschool period, thirty-eight to forty months.

Educators consider toddlerhood a unique stage because in each area of development—motor, cognition, language, social, emotional—toddlers differ from (but also overlap with) both infants and older preschoolers. Major theorists of child development, such as Jean Piaget and Lev Vygotsky, have defined key elements of toddlerhood.

Toddler Cognitive Development

Jean Piaget pioneered our understanding of cognitive development. He saw toddlerhood as straddling the first two phases of development: sensorimotor and preoperational (1971b). Babies, he argued, do not keep pictures or representations of things in their minds. They are naturally inclined to actively explore their environments, observing the sensory and motor qualities of objects. This gradually leads them to build expectations of and associations about things. At around eight to ten months of age, children begin to remember objects that are no longer in view. They can represent objects as symbols in their minds.

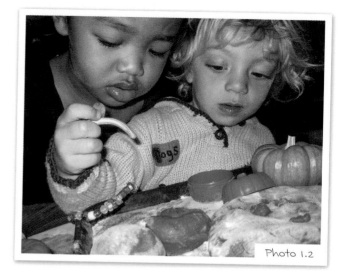

Photo 1.2

As children develop, they begin to explore their ideas about things, just as they explored the things themselves. Their representations of objects grow into what Piaget termed *schemes*: categories that can be compared and combined and used to pursue sequences of actions. Piaget called this second stage of development the preoperational phase (1971b).

Piaget stressed that it was the cumulative nature of development—one stage must be built on the next—that mattered, not just the ages when individual developments occurred (Rogoff 2003). But virtually everyone agrees that ages one to three form the transition between the two stages. It is during toddlerhood that children progress from exploring and observing physical qualities to organizing schemes and testing out hypotheses.

Where Piaget believed that cognitive development was driven by individual exploration, his contemporary, the Russian linguist Lev Vygotsky (1978), described children beginning in infancy as using the ideas, cues, and skills of others to move up through zones of development. The most important zone for Vygotsky is the zone of proximal development (ZPD), the one just above a child's current level of mastery. Adults or other experts—older or more skilled peers—provide a scaffold for children to climb up into the ZPD. He agreed with Piaget that, at the same time, children elevate themselves through experimentation and ideas.

Vygotsky also viewed development as fundamentally collaborative, arguing that children and experts meet in the ZPD. Children's ideas (their hypotheses), while often false, need to mingle with the knowledge of experts. A dialogue of ideas, he argued, is necessary for children's natural growth. Art is a natural forum for this collaborative model of learning; art promotes communication and flexible collaboration.

Toddler Emotional Development

Psychologist Erik Erikson (1963) stressed that a child's early years are the focus of building security, trust, and the beginnings of a self-image. In toddlerhood and young childhood, children become more conscious of their image of self and the image others have of them. This is the same period in which Piaget noted the development of abstract representation. Erikson identified the central work of this stage as finding a balance between autonomy (the drive to explore independently) and shame (the response to outside limits or disapproval). By the preschool years, this reconciliation process moves onward to the balance of initiative (generating and pursuing impulses and ideas) and guilt (accommodating the risks, responses, and restraints of the world around us).

Attachment theory (Bowlby [1969] 1982) goes further to suggest that infants and toddlers build trust and autonomy by exploring away from adults but also by continually returning to them. Children learn to understand and regulate their own feelings and impulses from this balance of freedom and structure. Further, for children to develop empathy, acceptance, and self-control—the basic tools of collaboration and interpersonal problem solving—they must first be secure in their own emotions and images of themselves.

Toddler Sensorimotor Development

Psychologist and occupational therapist A. Jean Ayres (1979) pointed to sensory integration (a child's way of interpreting and balancing stimuli) and motor planning (the brain and body's impulses to carry out physical actions or tasks) as the foundation for development. This perspective holds that temperament and constitution—the preferences, sensitivities, and style of exploring that we gain from our nervous system and body—form the basis of our emotional, cognitive, physical, social, and creative style.

Ayres emphasized sensory *integration*, because a person's mind and body must continually integrate multiple sensory inputs: what he is seeing, hearing, feeling, smelling, and tasting, as well as what he is thinking. Each person has a unique process of sensory integration. His arousal and regulatory systems—what he seeks out, what he avoids, what makes him organized and/or receptive, what makes him overaroused and/or

Different sensory integration styles lead to different ways of exploring.

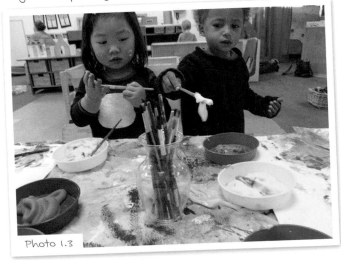

Photo 1.3

defensive—flow from his sensory profile. Both cognitive and physical development flow from the wiring of the nervous system. Because of these connections between body and mind, art plays a key role in helping children explore not just their sensory experience but all their actions and expressions.

Ayres's view of early childhood development clearly overlaps with Piaget's idea of moving from a sensorimotor mode of exploration to abstract reasoning. It also parallels attachment theory's focus on regulation. Infants and toddlers learn primarily through sensorimotor exploration. Sensory integration perspectives, however, remind us that infants and toddlers are still early in their sensory development. Everyone has a complex system of integrating multiple sensory inputs, and each of us has a range of reactions to stimuli.

Toddler Brain Development

Freud (1949), Piaget (1971b), and Vygotsky (1978) all theorized about the physical structure and functioning of the human brain. Freud saw a three-part model consisting of the id, the ego, and the superego. The id is the instinctive part of the brain we share with animals. The ego is the self-conscious, reasoning mind. The superego is the rational governor of the id. Piaget argued that, as children encounter contradictions to their emerging ideas of things, their mental process of reconciling contradictions causes the pathways in the brain to physically mature and become more complex. Vygotsky refined Piaget's ideas by suggesting that the brain is an innately interpersonal organ that develops by observing models of more expert behavior—that is, the behavior of older children and adults.

As their ability to observe the brain in action has increased, researchers have developed a three-part model of the brain that confirms these thinkers' ideas (MacLean 1990):

- The reptilian brain, or brain stem, governs instinctive behavior and survival instincts.

- The middle brain, or limbic system, governs emotions and how we make cognitive sense of them.

- The neocortex, which develops last, is where we do our abstract thinking and reasoning.

Recent imaging of brain activity has shown that it is the limbic system—where feelings, senses, and early sense-making intersect—that undergoes the most intense development during early childhood.

This phenomenon implies that our work with toddlers should focus on the systems that are most at play: emotions, emotional processing, and sensorimotor

development. We tend to think of toddlers as more rational than infants because they have language skills. But toddlers' brains are only beginning to build bridges to abstract reasoning and organization via emotional exploration—especially imagination—and sensorimotor experience. We may see lots of signs of emerging abstract reasoning even in young toddlers, yet we must keep in mind that the presence of these capacities does not mean toddlers can use them to organize, make sense of, or regulate their impulses and feelings.

How Views of Toddler Development Have Changed

The major theories of child development, all evolving over the last hundred years, have naturally seen generations of revisions, amendments, and challenges. Changes in how researchers study very young children and in technology for observing the brain have shifted our perspective and integrated once-separate disciplines of childhood support.

Two currents in research fleshed out and confirmed the concept of the brain and body as linked through the nervous system. They also established the idea

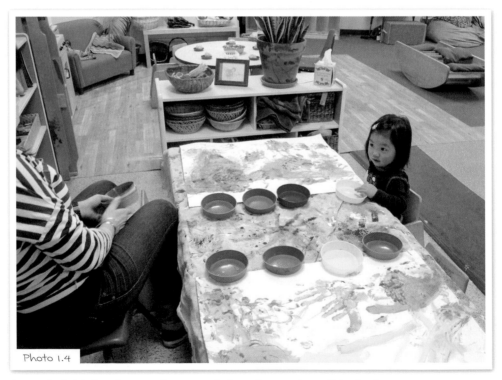

Photo 1.4

Recent child development research has focused on this fact: very young children use adults as mirrors not just to know what to do but also to build a sense of self.

that development in infants and toddlers operates in more complicated ways than early theorists believed.

In habituation studies, infants' responses to new and familiar experiences are measured through multiple physical factors, such as sucking rates or eye movements. This research has produced a compelling body of evidence that infants and young toddlers represent abstract symbols (or precursors) and organize schemes and hypotheses earlier than previously believed (Flavell, Miller, and Miller 2001). And electronic imaging of brain activity has explored the ways that positive and negative experiences can influence the development of emotional processing, sensory integration, and abstract thinking (Perry and Szalavitz 2006).

Brain research has confirmed Piaget's idea that the pathways in the brain divide and multiply based on how children use them. But it has also deepened our understanding of how different experiences can concentrate brain development in different sectors. The brain not only adds pathways to the areas that receive the most exercise but also prunes pathways in the areas that are not used. If children experience a great deal of stress, the reptilian brain and lower limbic system will experience greater activity and hence greater development. So high activity and development in the lower brain means lower levels of development in the higher brain, just as a preoccupation with one kind of learning or exploring may inhibit exploration and development in other realms.

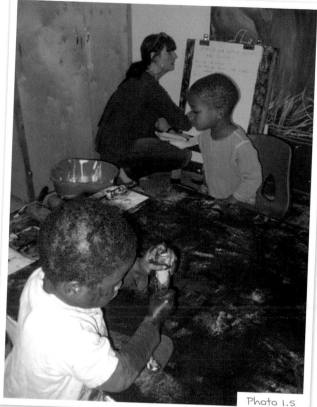

Photo 1.5

The implications of these discoveries are significant:

- Teachers can and should focus on providing a supportive and positive emotional environment in order to foster children's use of the developing higher brain.

- Development of higher brain functions in toddlers relies on comfort and security, as well as on exploring the links between senses, feelings, and ideas.

- Teachers can support brain development by appealing to different centers of the brain—language, motor, auditory, and visual, for example—to promote

balanced brain development and the connections between the different parts of the mind.

- Involving different kinds of learners in different kinds of experiences can help promote rich physical, sensory, and cognitive development for all.

It is important to note that Piaget and Vygotsky were right about many key points:

- Children are active learners who construct knowledge on the foundations of what they already know.

- Learning is interpersonal and collaborative; children need to learn from others and influence others.

- Children learn by seeing and replicating others' patterns of behavior and thinking as well as seeing themselves—their feelings and their actions—mirrored in others.

- Children of all ages develop by pursuing their ideas. They need opportunities to do things the right way, the wrong way, and any way they please.

Piaget was right when he described learning as largely a process of problem solving. We encounter contradictions or confusion and return to a balanced cognitive state by expanding our understanding through experimentation. Of all the lessons of toddlerhood, this one may be the most important to developing an effective curriculum.

CHAPTER SUMMARY

In this chapter, I described a basic approach to projects and toddlers in early childhood settings and outlined the major theories of toddler development, how they have changed, and what they imply for early childhood programs. In the next chapter, I present some basic goals and guidelines for applying these perspectives to setting up space, selecting materials, developing curriculum, and establishing partnerships for toddlers to explore creative materials.

Toddlers and Projects: Basic Practices

Chapter 1 reviewed some of the basic developmental ideas and theories of toddlerhood. In this chapter, I take a look at how an understanding of toddler development can guide your approach to supporting toddlers as they mature into organized project work. As you read more about practice, keep in mind two of the most fundamental points about toddler development:

1. Toddlers are in a fluid and dynamic stage of development. They are acquiring and refining multiple skills and capacities in a very short period of time. They mix younger and older styles of exploring and thinking in an overlapping pattern.

2. Infants and toddlers develop seeds of abstract reasoning and sequential organization earlier than adults tend to observe. As Katz and Chard (2000, 7) put it, "Many adults tend to overestimate young children academically but underestimate them intellectually."

RELATIONSHIP-BASED EDUCATION

Over the past twenty years, early childhood educators have proven again and again that children learn through relationships. They learn through care, observation, imitation, dialogue, debate, conflict, and collaboration. Relationship-based education sees the network of relationships in a program—between teachers and

children, between families and teachers, between families and children, and between children and children—as the core of the curriculum and the foundation of the learning process.

These principles hold particularly true for infants and toddlers. As we know from theories of sensory, emotional, physical, and cognitive development, toddlers are still highly attuned to physical and emotional nurturing. This is what attachment theorists describe as a *secure base*. While toddlers often show high interest in peers, adults act as the primary play partners and models, while also acting as care providers.

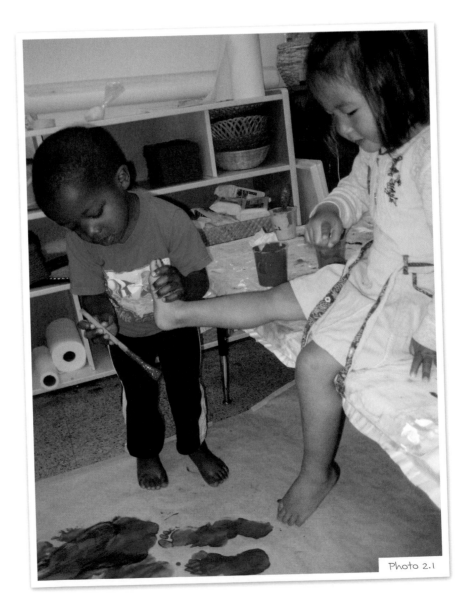

Photo 2.1

Teachers of toddlers use their relationships with children to help them find comfortable but stimulating patterns of exploring a school or care setting. This begins with separating from families and then establishing routines, favorite activities, friendships, and eventually group projects. Magda Gerber, the developer of the RIE infant-care approach, believed that education and care are intertwined for teachers of infants and toddlers; hence her term *educarers* (Gerber 1991). She also stressed that part of the nurturing relationship involves adults stepping back and allowing children to guide their own exploration.

Both RIE and the Reggio philosophy emphasize the core roles of trust and respect in relationship-based education. Establishing and developing relationships with children and their families is at the center of the curriculum. Showing trustworthiness by recognizing individual styles, strengths, preferences, routines, rituals, and values is essential to fostering learning and development. Tailoring the school experience to individuals is also the purest form of respect.

Brain research has confirmed that children learn a great deal from adult affect: adults' moods, expressions, and body language. When teaching art to toddlers, the teacher's main goals are

- to partner in the learning process with children and act as a model and pattern for exploration, and

- to cultivate and communicate a sense of authentic passion for the learning and exploring process.

Toddlers are wonderful to work with precisely because their sense of wonder is so easily activated. They take great delight in fostering partnerships with adults who can mirror their curiosity and excitement and guide them into new territory. Put simply, relationship-based teaching for toddlers means both finding your own connections to childlike discovery and offering increasingly sophisticated ways to channel it. Because children learn so much from adult affect, a relationship-based environment helps children learn emotional regulation.

REGULATION

The infant or toddler classroom can be seen as a laboratory for learning how to regulate one's engagement with the world outside of the home. Learning to say good-bye to parents and trust in the care of teachers advances children's emotional regulation. Finding their way into transitions and routines such as music or snacktime helps children learn to regulate their balance of internal initiative

with outside expectations. Encountering peers leads children to build skills of self-regulation—when and how to assert oneself and when and how to be patient and flexible.

And, most important to this discussion, a classroom full of exciting and varied opportunities presents an ongoing chance for children to regulate their patterns of exploration:

- when to do things with their entire body or just their hands, eyes, or voices

- when to be loud and boisterous or quiet and attentive

- when to stick with things and when to move on

- how to choose one thing first even if three tables of materials are beckoning

- how to take in multiple sensory stimuli and make a plan of action

Regulation in this sense is much like what is often called *organization*. But it also helps to think of this aspect of regulation as *decoding* sensory environments and materials. As adults, we understand the code of a classroom: this area has a couch and a bookshelf, so this is where teachers and children read books; this area has a shelf with baskets of rollers, cookie cutters, and molds, so it must be for pliable or gooey things like playdough.

But for very young learners, all the cues and suggestions of materials are much less familiar and distinct. They take time and work to figure out. Toddlers have a harder time than older children seeing groups of materials as individual but related pieces. An overcrowded bookshelf, for example, may not present itself as a selection of appealing reading experiences but rather as a bright and busy jumble.

So it is easy to see how organization and decoding affect a child's level of arousal and stimulation. If materials or areas call out to a child and make clear what can be done, a child will be more inclined to settle in and explore purposefully. If the meaning or use of classroom materials is not clear or if the environment is cluttered without purpose, it can promote wandering and over-stimulation. On the other hand, an activity or set of materials that suggests a *sequence* of exploration can inspire a sequence of ideas and actions. As young children learn to perceive the ideas behind materials and activities, they begin to foster their own ability to generate and pursue ideas.

A teacher's regulation skills—in terms of expression of emotions, organization of time and space, vocal tone and volume, and level of arousal—make up an important set of teaching tools. And although teachers are obviously (and thankfully) not in the same stage of development as toddlers, they are still learning. Their curious, evolving engagement with art and their own learning process form important patterns for their students' learning.

Since toddlers are deeply involved in their own emotions, art is fundamental to toddler development as a way of expressing and making sense of feelings. The emotional-processing value of art projects is key to their appeal and use. Children's initiative and ideas, the building blocks for later learning, begin with making sense of feelings.

PROCESS AND PRODUCT

Older children and adults are accustomed to making art with a goal in mind: they try to create a *product*. (In the larger culture, both fine and commercial artworks are often products for sale.) They start with a picture in their minds and try to express, evoke, or replicate it. In other words, they take an abstract idea and try to represent it as they see it.

But making art is also a process. It is the act of exploring with materials, observing results, and then exploring further. Even some professional artists—Jackson Pollock, for example—focus on the expressive process of art rather than on a predetermined product.

Of course, toddlers are much more attuned to process than product. The developmental path of toddlerhood can be viewed as a progression from process to product. While early childhood educators tend to focus on process over product, every part of the creative process is important for toddlers. The teacher's role is to structure art experiences that range from open-ended to goal-oriented in a leisurely but sequential order.

This journey begins with a focus on exploring materials. Building on Piaget's ideas, the art-focused curriculum of Reggio Emilia developed a concept of art as a language (Kantor and Whaley 1998). In this model, individual materials like glue or paint are likened to words—the "vocabulary" of art. Children must learn and explore the units of creative language before they can assemble them into something larger.

The connections between this view of creative development and our understanding of toddler language development are illuminating. And they imply, as does our understanding of brain development, that an important role of teachers is to help build bridges between process and product and between creative expression and language.

EMERGENT CURRICULUM

Reggio Emilia and the Project Approach are examples of emergent curriculum. Rather than bringing out the same materials at the same time each year based on the same themes, teachers in an emergent curriculum model will take these steps:

- observe the children's open-ended exploration or play and note recurrent and communal themes, interests, and topics
- develop ongoing but flexible materials and activities to respond to and help extend the children's ideas
- engage the children in planning, modifying, and documenting the curriculum
- observe the children's engagement with curriculum and modify it based on their responses and new ideas

The Reggio Emilia curriculum uses the term *Big Ideas*. A Big Idea includes things such as light, sound, rain, crowds, and so forth. In deciding which play themes to develop into curriculum projects, Reggio teachers look for the following:

- pervasive themes—those that come up again and again
- contagious themes—those that appeal to or emerge from a broad cross section of the group

Both the Project Approach and Reggio Emilia stress that teachers must play a guiding and decision-making role in emergent curriculum. They pick which ideas to focus on and which to leave. They also know that some themes do not take root or are only explored for a few sessions. There is no single, right balance to open-ended process and adult structure. Adult trial and error is a positive part of the process, not a sign of failure.

FROM CHAOS TO COHESION

Creative development among toddlers can be viewed as a shift from process to product but also as a move from an exploratory curiosity in both construction and deconstruction to a focus on organized construction. In other words, it is a journey from chaos to cohesion.

The distinction is important precisely because toddlers are interested in chaos. They push and knock things over. They take things apart. They move materials from one place to another and combine them in surprising ways. Chaos plays a vital role in toddlers' maturation. They move from sensorimotor exploration, which focuses on all cause-and-effect reactions, to the preoperational level, where schemes and concepts begin to govern exploration.

Toddler exploration often focuses on destruction and unraveling. Toddlers can be counted on to engage with materials in just the opposite way adults intend. When planning art experiences for toddlers, teachers must incorporate rather than discourage children's natural tendencies to explore materials in a multi-directional way.

Teachers must prepare for and welcome surprises, accidents, and experimentation. In other words, don't put out more paint than you are willing to see dumped on the table.

But of course, teachers mustn't foster toddlers' interest in chaos without looking for avenues toward cohesion. As Vygotsky (1978) suggested, one of the important roles of a teacher is to provide a scaffold from chaos to cohesion. That is the business of the projects described in the next three chapters. And it is up to each teacher, group of teachers, or program to set its own boundaries and limits around messes and deconstruction. Children thrive on both freedom and structure. Knowing what you may or may not take apart or where and when you may make a mess (along with how loud, fast, or rough you can be) is an important part of the learning process.

REPETITION AND VARIATION

Repetition is seen as a core trait and need of toddler development (Perry and Szalavitz 2006). Piaget observed infants experimenting repetitively with objects to build schemes. Freud, and later Erikson, saw children working out emotional themes repetitively to resolve emotional conflicts. Attachment theorists suggest that children need to explore away from care providers and return to them over and over again. From the womb on, repetition drives early development—through rhythm, predictability, routines, habits, traditions, favorite games, stories, and materials (Honig 2006).

But each of these theories of childhood also confirms what we see in the toddler classroom every day—very young children need variation. Variation—or contradiction—is at the core of Piaget's concept of cognitive growth. Brain

research sees challenge and new experience as fueling the physical growth of the brain. How, then, do we balance these contrasting needs?

In general, the younger the child, the more we want to lean toward support and familiarity over challenge and novelty. It cannot be stressed enough how much young children value and thrive from returning to experiences and exploration. This is especially true in a culture where teachers often feel pressured to come up with creative and exciting new projects regularly.

My aim in this book is to help you guide children from that secure base toward not just more novel experiences but also to a toolbox of skills and habits for inviting, decoding, and exploring new experiences. This book will help you build a scaffold, in Vygotsky's sense, from repetition to variation and design a sequence of experiences for children that help them develop sequences of experiences for themselves.

MORE WITH LESS

The next three chapters discuss these keys to a toddler art curriculum in detail:

- starting with exploration of individual materials
- introducing new tools, materials, or steps intentionally and gradually
- using observation and documentation to tailor decisions, direction, and pace
- collaborating and dialoguing with children to extend and enrich their learning and make choices on future directions

In short, art with toddlers is about doing more with less. Rather than thinking of projects as individual products to create for individual occasions, think of sequential cycles of exploration built around a common developmental theme or even a common material. It is better to repeat materials many times, with subtle changes, variations, or sequential evolution than to start over or shuffle materials or projects.

Two general themes to keep in mind when fostering sequential, evolving art exploration with toddlers are (1) time and change and (2) breaking down big things into smaller steps.

Time and Change

Repeating explorations over time provides toddlers with their first model of a project. As Piaget (1959) noted, it is children's observation of surprise or change that also first suggests evolution or steps.

The toddler teacher must learn how to incorporate time and change into the curriculum planning process. In its most basic sense, this suggests that teachers foster a leisurely and flexible approach to exploration—both in the moment and over many sessions. Observation and conversation help promote an unhurried, curious approach.

And this idea also extends to materials. As you can read about in the Wax Resist Project and the Canvas Project (see chapters 3 and 4, respectively), keeping and using the same materials over time can help children discover changes that define projects. They begin to see how their repeated experiments pile up or transform into something larger.

Breaking Down Big Things into Smaller Steps

A project is a matter of assembling small pieces into a larger whole. But it can also be a process of setting out to create a vision or idea, especially as children's abstract thinking skills advance. That is, a project involves taking an image or idea of a product and breaking it down into the active steps necessary to make it. This is why it is so valuable for young children to disassemble and deconstruct things. It helps them build both abstract and concrete models of how things are put together.

In other words, helping children create projects around their ideas involves working in reverse before moving forward: teachers help young children take a whole idea and break it down into pieces—or steps. These pieces are then assembled back into something whole—a model of an idea, such as the projects I describe in chapter 5. Younger and older children alike tend to go back and forth—putting things together and taking them apart—as they build a model of problem solving and inquiry.

Projects focused on younger toddlers—ages one to two and a half—lean more heavily on open-ended sensory exploration, turning accidentally into finished products. Older children move naturally into trying to break down an idea to represent. Yet even very concrete, sensory-thinking toddlers are beginning to try to line up strings of abstract ideas. Likewise, kindergartners and older children continue to discover and construct schemes and hypotheses through unplanned, sensory-based exploration.

TWO VIEWS ON REPRESENTATION

The emerging ability to represent the world through symbols, perhaps more than anything else, drives children's journey from chaos to cohesion. However, there are many ways of representing the world and just as many ways for teachers and programs to foster representation.

In Reggio Emilia and in the Project Approach, children are encouraged to express their emerging thinking through representational art projects. Creative inquiry into self, life, family, school, and the surrounding community is aligned with learning discrete skills. Children learn to express an idea, negotiate a plan for pursuing it, gather materials, create sophisticated symbolic models of the thinking process, and record the end product.

Representing the world through art offers many strengths:

- It builds both abstract thinking and fine-motor skills.

- It encourages regulation through ongoing investment in meaningful work.

- It helps children break big ideas into steps and sequences.

As a result, representing experience through art and writing is linked directly and naturally to academic skills as well as to the sense of self in a community.

But early childhood education, especially in America, is also based largely on play. Children learn to represent experience, ideas, and feelings through pretend games and scenarios. This form of representation, while not as obviously aligned with art projects, is also vitally important:

- It helps children build links between the emotional processing of the limbic system and the abstract reasoning of the cortex.

- It fosters gross-motor and fine-motor skills.

- It promotes a growing understanding of affect, motivation, and interpersonal dynamics.

- It encourages social collaboration and negotiation.

- It builds narrative capacities, which are, like fine-motor skills, key to writing.

Think about the study habits we associate with artistic and literary representation: expressing an idea, negotiating a plan for pursuing it, gathering materials, and recording the end product. All of these steps are or can be part of imaginative play as well.

Teachers can help children negotiate roles and the use of space as well as develop characters and plot. They can support children's planning and organi-

zation by helping to gather props or costumes, even suggesting the construction of an impromptu stage or theater (Wanerman 2009). Teachers can also support children's collaboration on narrative and sequence. In so doing, teachers can incorporate many of the academic skills offered by art.

It is important, then, to incorporate symbolic play into art experiences and vice versa, because pretending is a laboratory for processing, representing, and expressing emotional, social, and identity development. In the Abiyoyo and Lion Head projects (see chapter 5), you will see how art can be a link between symbolic play, drawing, and writing.

THOUGHTS ON TEACHERS' LANGUAGE

When a child shows a teacher a finished work of art, the natural response is often, "What is it?" Some very young children will, without adult prompting, tell an elaborate story about what looks like a page of scribbling. Talking with children about what their art represents helps support a young child's emerging symbolic skills.

Educators often feel that it does not support children's development to stress adult ideas of representation (Bos 1978). In a similar vein, there is disagreement about whether adults should demonstrate their own drawing skills with children. For some children, it can limit their own process of development and discourage them from trying to represent ideas in their own ways. There is no one right recipe. What matters most is cultivating ways of encouraging children's own initiative and confidence.

To put it another way: a child's growth from process to product should focus on the child's ideas. It should not be about giving up internal ideas in order to meet adult expectations. But as Vygotsky argued, children naturally seek to learn specific skills from older experts. Using others as models is as natural to the learning process as making one's own choices.

This implies that teachers are wise to focus on process but also to present and talk about finished products. When observing and remarking on children at work, you can support them by reflecting on what you see. For example, you might say, "I see you making dark lines up and down."

Likewise, it is natural to want to praise the results of children's work, as when you say, "What a beautiful painting!" Encouragement, which focuses on acknowledging the child's effort or response, is seen as fostering children's own initiative and ideas (Nelsen, Lott, and Glenn 2000). Encouragement may also sound like

this: "You worked on that for such a long time," or "You look like you feel really good about your work." Of course, this sort of language does not address emerging representation. But here you can also focus on the child's process. Instead of "What is it?" you might ask, "What does it remind you of?" or simply, "Tell me all about it."

There is no need to be disingenuous. Taking real interest, showing real excitement, and sharing your real responses to children's art is part and parcel of the authentic relationship on which you build your teaching. When you are moved to honestly say, "You drew your family!" or "What a beautiful picture!," it will have a positive effect on the child.

Keep in mind your long-term goal: to break down the complex sequence of representational projects into manageable steps. This can also apply to individual teacher-child partnerships. A teacher might support a child who asks for help drawing faces by breaking the task down into a logical sequence of steps that focus on concrete elements:

"Do you want to make a circle or a square for a head?"

"Do you want to add eyes or ears next?"

"Where will you put the eyes?"

"What shape do you want them to be?"

"What color will they be?"

And so on.

There are many positive aspects to celebrating children's art by making it meaningful and recognizable (some of which are incorporated in the Big Pumpkin Project in chapter 3). Nevertheless, I feel strongly that teachers should reserve their time and effort for advancing the active learning process and giving children more choices about presentation. Likewise, always drawing for young children, even at their request, or walking them through goal-oriented projects aimed at older children misses the main goals of a project curriculum.

WORK AND PLAY

Before continuing, I want to flesh out the definition of play I use throughout the book:

- It can be self-initiated or negotiated.

- It focuses on building self and satisfying self.

- It can be self-directed or directed through negotiation.

- It is often built on themes, preferences, and/or the initiative of the player(s).

- It often employs toys, games, and other discretionary objects.

- It focuses on and fosters joy.

- It can be exhilarating and/or relaxing.

These definitions contrast in many ways with the definitions of *work*:

- It is dictated from outside or by norms of groups/community.

- It focuses on building roles in the community and contributing to community.

- It is directed by others or by rules or rituals.

- It often employs tools and other functional objects.

- It focuses on and fosters discipline.

- It can be draining or confining.

We tend to think of children as attuned and receptive to play but resistant to work. Just think about the transition in your program from open choice to cleanup time! But teachers and families also know that children have a positive interest in work. When they play they often seem to be going about a job. They pretend to change a baby's diaper, gather materials and transport them around, and try to figure out how two Legos go together. And children often respond with great enthusiasm to the prospect of a "special job" like taking care of plants, being the teacher's helper, or preparing a snack in the kitchen.

Look again at the list of characteristics of work. Children love to test and confirm their skills and competence. They like a defined, meaningful role in the community. They are fascinated by tools. And as we have seen, learning from adult models and getting the right answer appeals to many children in many ways.

Art is a means to help children integrate work and play in ways that take advantage of both. Many adults are drawn to art as an avocation precisely because it integrates work and play! This book shows you how to use art exploration to help children better understand and appreciate the joy of work and the serious value of play and how to work playfully and play meaningfully.

DOCUMENTATION

I have touched on how documenting children's work plays an important role in both the teacher's and children's guidance of art projects. Documentation is the subject of many valuable books. There are many different uses, approaches, and considerations to documentation. I will sift out the important aspects of documentation as I discuss specific projects and offer examples of documentation from my classroom.

Documentation has many important uses:

- for teachers to revisit, reflect, and plan for individuals or groups
- for teachers to learn more about and plan for an individual's learning style, temperament, and preferences
- for children to preview, review, and revisit their process—often during the process
- for groups to share their process and outcomes with the school community and their families
- for teachers to help make the curriculum's learning and developmental value and goals clearer to both the children and those outside the classroom
- for helping to structure and mediate the teacher's engagement in the process and regulate the balance of active engagement and observation (both in the moment and over time)
- for children to explore the role of art in the community
- for helping children learn how to represent their worlds and work

CHAPTER SUMMARY

In this chapter, I've provided background information on relationship-based education and how it supports the Project Approach. I've explained some of the key concepts on how to manage projects with toddlers, such as providing time for repetition, breaking down large tasks into small steps, and carefully choosing materials (and deciding when to introduce them). Play is children's work, and teachers need to support that work. In the next chapter, I explain how to set up your space and present a number of projects.

First Steps: Exploring Project Materials and Themes

My experience with toddlers and art is tied to the rhythm and structure of the toddler program in which I have taught for twenty years. Supporting children's overall immersion in the school experience and their comfort with new adults forms the backbone of the early art curriculum at The Little School.

Very young children are focused on learning—from adults and the environment—how to operate and behave in a classroom. One way teachers can foster children's feelings of safety and comfort as well as their creative exploration is by helping them develop a clear and positive understanding of the art area, materials, and how they are used.

DEVELOPING A STUDIO OR ART SPACE

Space to move around, gather and store materials, and make a mess can be hard to come by (and protect!) in early childhood environments. Shared space, limited space, or fragile space can make it hard for teachers to encourage free exploration of messy materials. Small art areas can limit what sort of projects or tools teachers can use.

Nevertheless, using art as a primary lens for children's learning requires a commitment to developing and maintaining an effective space for creativity and representation. It should also support children's ongoing exploration and their natural temptation to explore materials with their senses.

In Reggio Emilia, the *atelier* has become a part of many infant-toddler centers and preschools. The *atelier* is a studio, or workshop, furnished with a variety of expressive materials to encourage visual exploration and representation. It is a place filled with orderly shelves of inspiring materials. A special art teacher, or *atelierista*, helps children conceive of and organize art explorations.

Photo 3.1

Keep in mind these key ideas when developing an art space:

- It should speak to children about its importance and use. It should be a dedicated creative space for much of the day and have ample materials and tools available.

- It should define children's movement through space, engagement with materials, and opportunities for exploration. Materials on shelves should invite and organize children's use. Room to move and experiment should be maintained. The aims of specific projects should be expressed through spaces and materials. Labeling shelves, keeping materials in the same defined containers and spaces, and regular cleaning and straightening will also help children learn to use the space in an organized and respectful way.

- It should invite and accommodate sensory exploration and messes, and it should also suggest ways of maintaining order and cleaning up. Containers for trash and tools to be washed should be regularly available. Drop cloths, tile floors, Tyvek (special coated paper), or oil-cloth lining on the walls and washable surfaces invite messes and make them easier to clean up.

- It should feature, if possible, sources of or interactions with natural light and materials.

- It should contain a balance of rotating and permanent materials. Toddlers seek out repetition and variation, so they will benefit from a mix of materials they can almost always find—construction paper, crayons, scissors—with changing, suggestive, or challenging materials, such as rubber stamps, glue sticks, or hole punchers.

Teachers can use children's understanding of fixed and novel elements to call out and define specific projects. It is important throughout the life of the art area for teachers to consider and communicate which materials are self-serve, which require teacher support, and which are only used by adults.

The Easel: Mastering Separation as Art Project

The easel always draws children's passionate attention during the early days of a toddler class. This makes sense. It is a defined area where you can get away from traffic and have some space to yourself. You can observe the world from a perch, as artists have done since easels have existed. Children also seem attracted to the gross-motor opportunities of painting standing up, which facilitates expressing lots of big feelings and energy. Toddlers are drawn to sensory exploration of materials, so touching, moving, squishing, even smelling the paint occupies much attention and energy.

WHAT YOU WILL NEED

- easel(s)
- easel clips
- brushes and containers of various sizes
- various kinds of large and small paper
- tempera paint, watercolors, crayons, or other supplies for drawing and painting

Photo 3.2

The paint and easel may seem familiar to children. Some, but by no means all children, have an easel at home or have encountered one at a playgroup or activity center. Large quantities of paint and freedom to make a mess also seem to offer novelty to children. (Certainly the interplay of making a mess and washing it off, especially in a sink they can control, appeals to toddlers!) For whatever reasons, whatever combination of familiar and new, the first art project in our toddler class revolves around children finding time and space at the easel to make dark lines, heavy circles, dense shapes, and feathery outlines. Negotiating space and collaboration with peers happens naturally and right away.

Children are already spontaneously establishing and responding to a balance of novelty and familiarity, repetition and variation. These explorations help children and teachers organize and implement early projects.

The Role of Messes in a Toddler Program

My approach to curriculum, it goes without saying, celebrates making and exploring messes. With my coteachers, I explored how to set up an art or studio space to make this messy curriculum easier for teachers. Communicating with families to make your priorities and practices around messes clear is an important and rewarding part of a focus on creative exploration:

- Make your broad goals and specific plans clear up front. In a parent meeting, newsletter, or blog post, or however you communicate with families, share your overall emphasis on art and sensory exploration and their benefits for development and learning.

- Work with families to set up a mess-making system. At my program, we try to offer several ways for families to work around messy clothes. We keep commercial smocks as well as old adult T-shirts in the classroom. But since many children would rather not paint than wear unfamiliar clothing, we also ask families to keep a set of extra clothes on hand. We have also sent out more specific appeals for children to bring in a special hand-me-down shirt of their own to keep on site or pick some old clothes that can get paint on them.

- Share the fun and value with families along the way. Be sure to invite them into the classroom to enjoy the children's explorations. Share pictures and quotes of the process along with finished works, on-site and online if you can.

- Be firm but flexible. Work with each family to convince them that messes are worth the work. But also be prepared to accommodate surprises. Children with a birthday party or family event to go to after school may arrive in special clothes (watch out especially for drips on new shoes) and need some extra attention or effort.

HOW IT WORKS

Teachers need to think carefully about presenting color and texture in an evolving sequence. Since children devote so much observation and initiative to mixing colors, they thrive from opportunities to work in stages. To apply the Reggio Emilia idea of art as a language, monochromes and primary colors can be thought of as simpler words and color mixing as compound words.

One of the most basic variations to provide early in the year at the easel is variation in color. Your first impulse in this direction might be to offer combinations of primary colors so that children can create delightful purples and greens. This, of course, will further the children's thinking and learning. Since variation in color is also an important basic sequential exploration project, you can use many mindful and creative methods to gradually sequence the availability of colors.

Children can explore black, white, and gray with great excitement for long periods of time. Think of the classic infant mobiles with their basic black and white patterns. Muted tones such as brown and dark green are close to the earth and connect well with other sensory explorations of toddlerhood. They provide a fascinating thread of exploration as well. Offering white or black with other colors will take toddlers in surprising directions.

Monochromes lend themselves well to the exploration of positive and negative space, a key element of art for children and adults alike. (Positive space is created by putting color where you want it. Negative space is created by leaving color out. Both can create shapes and images.) Exploring the contrast between solids and the spaces between them, between light and shadow, between what appears to be up close and what seems far away, helps build a foundation for more sophisticated comparisons later on.

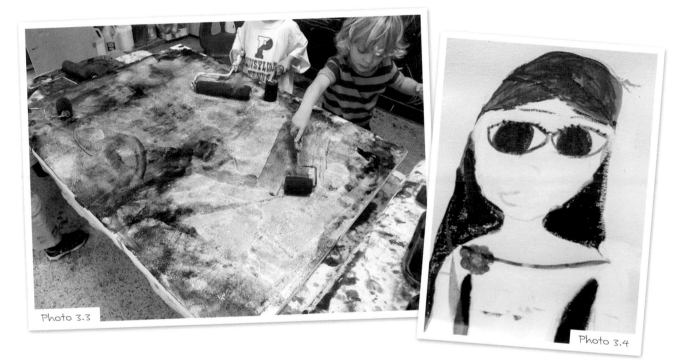

Photo 3.3

Photo 3.4

At The Little School we tend to start many projects, such as the Canvas Project (see chapter 4), with blacks and whites and then move on to earth tones. Likewise, we tend to introduce single colors before mixing them, but this is not a formula or a rule. Remember that the ultimate goal is to be observant and responsive to the group you are working with and in what directions their interest, exploration, and questions point.

Keep in mind, also, that you are not confined to varying just paint or color. Tools, background materials, and position or orientation of work also can be varied in ways that provoke wider exploration. Changing the color of the paper from white to black or brown, or using newspaper or other kinds of paper with existing patterns, can affect children's sensitivity to positive and negative space. Using objects as stencils or templates entices and inspires toddlers as well. (Stencils have a window inside that can be filled in; templates can be traced and leave a negative image.)

Here's one very simple example. Large, prepackaged picture frames often come with mattes divided into several windows to allow multiple photographs. You can clip one of these mattes over a piece of paper at the easel to form an inviting exploration into space and composition. Offering different tools, such as spray bottles or sponges, will extend the project over several sessions.

You can help integrate gross-motor and fine-motor exploration for children. You can also accommodate and extend children's basic sensory and exploratory styles. These goals can be accomplished by inviting children to stretch up high with long brushes, lie down and draw while supporting their trunks, or climb on stepladders or balance beams and paint something on the ground. With these variations, satisfying and regulating sensorimotor experience can be incorporated into children's creative exploration.

Sensory Integration Challenges

When you are planning and implementing projects, it is vitally important to consider sensory styles—how children approach and respond to materials. Some children will need lots of opportunities to dip their fingers in paint or glue and discover the sensations in materials. Other children may need time and support to approach materials or experiences that make them feel wary. They may observe teachers and peers and try one tiny step at a time, for example. You might consider providing gloves or a very long paintbrush to keep these children's hands away from wet and messy items.

In relationship-based education you must learn each child's strengths, preferences, and challenges and then help individuals learn to work at their own pace, in their own way, and with lots of support. Because of this, you must make careful choices about the following factors:

- light
- color
- sound
- texture
- motion—how movement is encouraged and guided

Teachers tend to associate bright cheery colors with childhood and strive to make classrooms upbeat, welcoming, and exciting. But it can be challenging for children to decode learning environments and stay focused in a highly stimulating environment. So you must be sure to consider the overall effect of the visual elements of a room—what each one suggests, says, or offers to the students. Think about how each element presents the curriculum, learning priorities, and values of the program.

Art projects, by their nature, tend to feature lots of stimulation. It is important to reflect on how many materials to introduce, how much color or ornament to use, and which qualities are most important for each learning experience. Beyond that, teachers of toddlers must prioritize where, when, and how they want to use surrounding stimuli.

The art table often sees me taking dictation with crayons on construction paper as children describe their feelings about separating from their parents and families. In this way, the first weeks of a toddler class can inspire young children toward using art and writing as ways of expressing and mastering challenges and new experiences.

I see toddlers constantly using art as a means of expressing or making sense of feelings—even before they assign symbolic or representational meaning to it. Where mastering separation from families is concerned, children typically love to use the art area to make something—a page of stickers or a crayon scribble—to give to a parent whose departure has inspired sadness. When children dictate notes or letters to family members, art, emotional expression, and literacy develop hand in hand.

Toddlers often demonstrate an early sense of sentence structure, narrative, and voice in these notes. Sometimes a teacher will talk with a child and write for several minutes, and the result will read, "Daddy! Daddy! I want to write Daddy!" Likewise, children who feel angry or frustrated about separation often use crayons or paint to work out their aggression by making dark, busy lines or tip-crushing dots. This will often lead to early interpretation. "It's a storm!" a child will say out of the blue, or "Big crash!"

One very simple way to support children emotionally during art explorations such as these is to focus on the importance of the art-making process rather than the child's feelings. Responding with authentic interest, asking questions, making sure there are enough materials, and hanging finished work where it will dry safely subtly reassure children that their feelings are healthy and normal and that they deserve respect and support. The entire process acts as a model of emotional resolution.

As children begin to try to represent ideas graphically as well as symbolically, they often talk about early shapes and figures they have drawn in emotional terms: "A girl. See? She's crying." And as they begin to act out stories and roles, art and writing can enter their games as scripts or storyboards. They can include records of dialogue and negotiation, signs for areas or constructions, instructions to performers or crew, and sets and props.

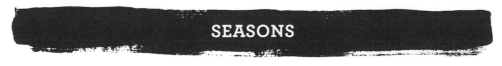

SEASONS

Since children use art to make sense of experience, teachers naturally want to promote those connections through enriching experience and representation,

often involving an emotional experience like separation from family. But art also incorporates the larger world, to which toddlers are becoming more and more attuned daily.

As summer turns to fall, the seasons and the weather are always sources of interest and discussion. Seasonal changes and traditions provide wonderful cues for exploring art. Teachers look to and listen to the children to draw out their questions, observations, and interests around seasons.

The seasons provide multiple opportunities for shifting colors in the art area. Primary colors—splashes of blue, yellow, and red—seem to fit the children's mood at the end of summer. As the days grow shorter and the skies darker, at The Little School we find chances to incorporate gray, brown, black, white, and combinations of these colors as well as focus on green, orange, red, and brown and their interaction.

Photo 3.5

We invite families to bring in artifacts such as dried leaves, squash, pinecones, and acorns to inspire thoughts about transformation. And of course our book area is alive with red, brown, and orange book covers—Ehlert's *Red Leaf, Yellow Leaf* (1991), Maass's *When Autumn Comes* (1992), Titherington's *Pumpkin, Pumpkin* (1986), Risom and Scarry's *I Am a Bunny* (1963), Rockwell and Rockwell's *Apples and Pumpkins* (1989), and Silverman and Schindler's *Big Pumpkin* (1995).

We like to bring a large pumpkin into the classroom in fall. Besides offering the connection to the cycle of nature, pumpkins give groups of children the chance to lift and move something heavy. Pumpkins (as well as colored leaves and other artifacts of the season) then find their way to the art table.

Photo 3.6

We often paint a real pumpkin, or cover it with tissue paper and liquid starch, and help the children represent a large pumpkin with paint. Painting large leaves or painting with leaves, branches, twigs, or even flowers can provide a simple yet evocative variation.

Autumn is a time of year when we often think of adding natural materials, like sand or even dirt, to the paint or merging our art and playdough areas to paint clay. We often paint with pine bristles or other twigs. Of course this can be done throughout the year, but we find that it meets children's natural instincts in late summer and fall and again in spring.

Rain Painting: Exploring Weather, Time, and Texture

Here is a project I often do during rainy falls or winters.

WHAT YOU WILL NEED

- a large piece of white or light-colored poster board, matte board, or cardboard
- several jars of powdered tempera and containers for mixing up various quantities
- spoons or other tools
- a large drop cloth or tablecloth
- a hard, flat surface that can be used for a few days (the lid of a large storage container or sensory bin works well)

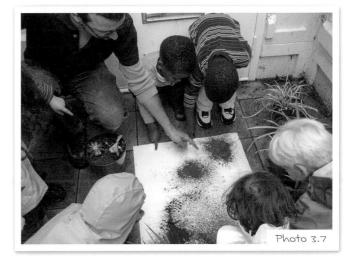

Photo 3.7

HOW IT WORKS

On a rainy day, set up the paints, containers, and spoons on the drop cloth by a door that leads outside. Set the poster board up on drop cloth on top of the hard surface.

Bring small groups of four or five to the work area at a time. If it is not very wet and cold, you can do the project outside in the rain. Each child can spoon or pour powdered tempera on the poster board.

(NOTE: Before you start the project, think about how you want to guide time and the quantity of materials. Think also about different tools or materials you can offer children who have more or less fine-motor development.)

Slide or leave the poster board on its hard surface out in the rain. Use an hourglass or timer to track how long you leave it there. In a heavy rain, you will want to leave it outside for no more than five minutes. In a drizzle, you can leave it out for up to half an hour and check it periodically to decide when it is done.

This project can be extended in several ways:

- Try putting a few pieces of poster board outside for different lengths of time over the same day.

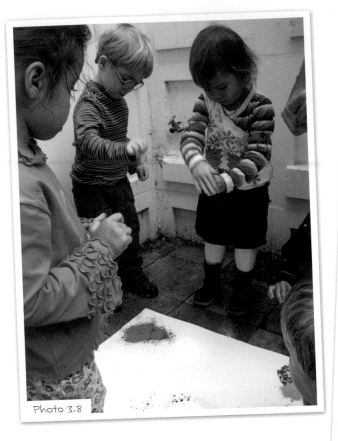

Photo 3.8

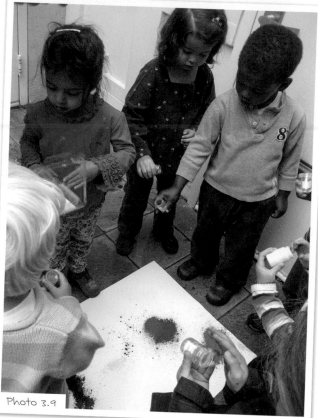

Photo 3.9

- Try putting different paintings out for the same amount of time on different days.

- Let one painting dry, and put it back out in the rain another day.

- Bring a painting in from the rain, add more powdered tempera, and put it back outside (either immediately or after it has dried).

- Use a finished rain painting as the beginning of more exploration at the art table, such as painting with tempera.

- Cover parts of a painting with different objects before you put it outside in the rain.

- Use a sequence of colors—monochromes, primaries, pastels—over several sessions.

- Invite the children to use paintbrushes, sponges, or other tools to manipulate the wet painting once you bring it inside.

EXPLORING PAPER

In *From Bauhaus to Our House* (1981), Tom Wolfe describes an exercise that artist Paul Klee conducted with first-year students at Bauhaus, the legendary German art and architecture school in the 1910s. He gave each student a piece of paper and asked him or her to make something with it. The students, eager to show their design and engineering skills, tended to fabricate ornate and complex replicas of buildings or monuments. But the student who received Klee's highest praise was the one who simply folded the paper in half and stood it on the table.

Photo 3.10

This reminds us that paper is not simply the surface or background for an art exploration—it has multiple unique qualities that are ripe for children's exploration. It has remarkable strength mixed with fluidity and flexibility. It can be molded to multiple shapes even by toddler hands. And it transforms dramatically when exposed to other elements, such as heat or water. As the children explore paint and color early in the toddler class, I also take side trips to explore the various learning opportunities of paper. No other art material can be piled up in layers, attached with a variety of media—from water to staples—or so easily broken down.

Construction and Deconstruction

We know that toddlers are drawn to construction as well as destruction. Paper is an ideal medium for both, and it is adaptable to different levels of development. Children who are just beginning to develop scissor skills, for example, find ripping paper (or combining cutting and ripping with scissors in hand) irresistible.

Children are delighted by an invitation to destroy something, since such acts are so often prohibited. (As I mentioned, boundaries and expectations must be made clear—projects that are to be preserved must be presented as such. And projects that invite children to deconstruct must be presented clearly as well.)

My colleague Tim Treadway created a paper-ripping project that delights children year in and year out. He draws a simple shirtfront and tie on a piece of easel paper and tapes it to his own shirt. He joins children at the climbing structure

and slide and tells them with a mischievous twinkle, "This is my brand-new shirt. Make sure you don't rip it." Since the toddlers recognize that the shirt is not real, and they pick up on Tim's humor, they quickly decode the "project"—to grab and tear the shirt as they go down the slide. Tim then responds with mock indignity, much to their delight.

Note here that the art project is nested in dramatic play and motor exploration. There isn't much artwork going on, unless you want to call it performance art! But it is an artful way of uniting imagination and movement and an active way to engage children in art. A narrower version of this activity often takes place at the art area with a greater emphasis on exploring materials. Teachers can offer paper—sometimes scraps of previous projects—and invite children to tear it. The shreds can then be saved for a later step or even another project. These concepts come together in a project that combines exploring seasons, deconstruction and construction, the qualities of paper, and paint.

PROJECT

The Big Pumpkin Project: Exploring Seasons with Paper and Paint

Fall is a time of looking outward to the changing seasons and the series of cultural rituals and holidays that mark the end of the calendar year. Even very young toddlers show interest in falling leaves, pumpkins, and of course, Halloween. This project uses the themes and images of the fall to inspire children's engagement with the natural and cultural world around them and to explore materials.

WHAT YOU WILL NEED

- two large pieces of butcher paper
- a black marker
- tempera paints and easel-sized brushes
- shallow containers for paint

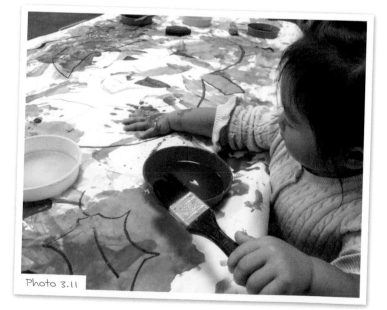

Photo 3.11

- several sheets of newsprint or other scrap paper
- a stapler
- string

HOW IT WORKS

The first part of the project revolves around exploring fall colors with paint. Cover the table tightly with one large piece of butcher paper. Draw leaf shapes around the edges of the paper and a large pumpkin or jack-o'-lantern in the center.

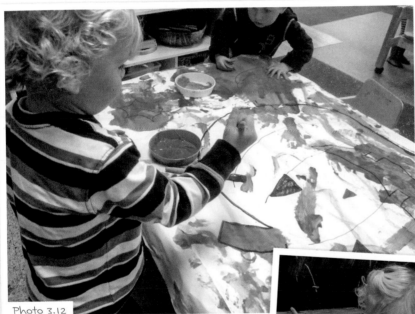

Photo 3.12

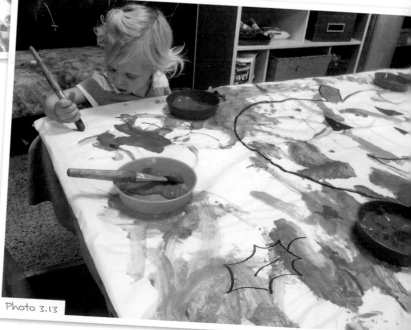

Photo 3.13

For several sessions, offer combinations of yellow, red, orange, green, and brown paint; as always, think carefully about which color combinations work well together and between layers.

After two or three sessions, put the first piece of butcher paper aside (or hang it where the children can see it), cover the table with a fresh sheet, and repeat the same steps, so that you now have two more or less identical painted pumpkin outlines.

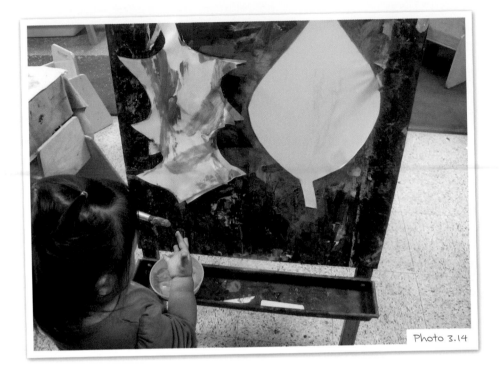

Photo 3.14

The leaf shapes can be cut out and offered to the children to explore at the easel, with real leaves, or at a light table.

Next, cut out the two painted pumpkins, and staple them together (back to back) about half the way around, leaving a large opening on one side.

Invite the children to rip and wad the newspaper or scrap paper offered on the art table, and collect it together. Depending on how much time you have or want to devote, children can stuff the wadded paper right into the opening of the pumpkin, or they can rip, wad, and collect it for a session or two and observe how much more space the wadded paper takes up compared to when it was flat. In either case, stuff the big pumpkin with the wadded paper, and staple it shut.

If you have space, have the children help you staple a long string of yarn onto the stem of the pumpkin, and hang the pumpkin above the art table.

Although the end point and this last step are more teacher-guided than usual, the project still focuses primarily on exploration and discovery. It offers the children choice and a variety of options in the early steps. And the excitement and intrigue of creating a finished, familiar, three-dimensional piece of art in such a short and simple sequence contributes to the children's investment and engagement with process.

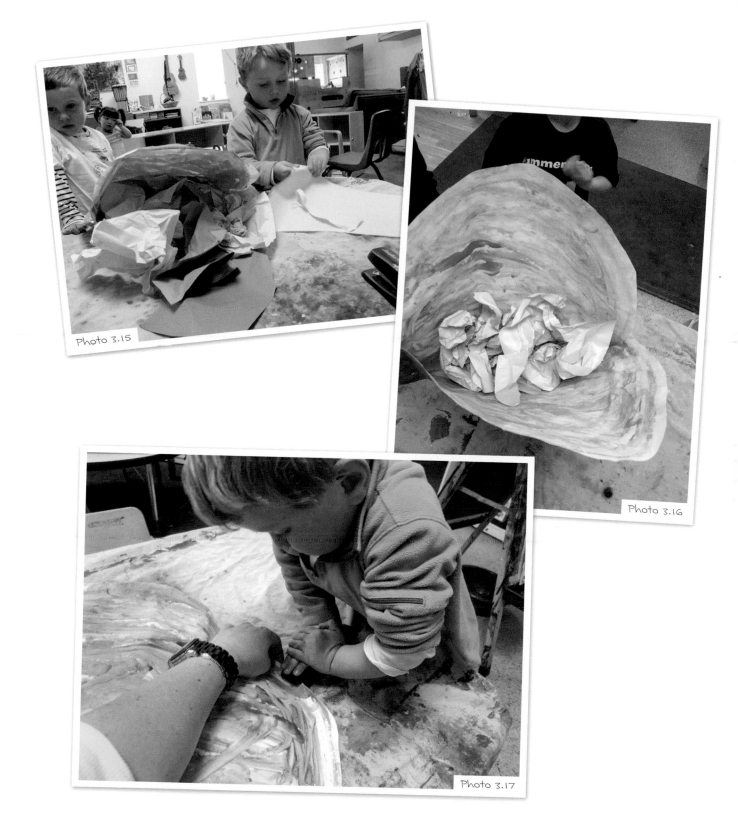

Photo 3.15

Photo 3.16

Photo 3.17

Soaking

Paper is also unique in that it absorbs liquid and color and goes through significant changes in consistency. There are many ways to experiment with soaking paper. Of course, painting or drawing with ink involves the paper absorbing liquid. We tend not to notice it when children use markers, but who has not seen paper buckling, tearing, and wrinkling under the brush as layer on layer of paint breaks it down? Children often show fascination and curiosity when helping to clean up spills with a towel. Using this natural cue, you can see how putting paper into liquid makes a logical jumping-off point since it makes few demands on fine-motor skills or sequencing capacities. Here, art and science exploration can overlap, as you can use different materials with varying properties—paper towels, tissue, and cardboard, or foil, wax paper, and cellophane, none of which will absorb at all.

You can continue to follow this basic sequence by offering small containers of water along with paper. This can form an early sequence of exploration around the favorite exercise of fingerpainting. Children can dip their fingers into small containers of water or pour it directly on the table or paper. Next, the water can be colored or swapped for paint. Finally, as children discover the basic process of moving paint from the container to the surface, you can increase the fine-motor challenges by introducing spoons or wooden sticks. By introducing the media and tools in sequence, children can find their own patterns of exploration, which they will repeat and refine countless times over.

Keep in mind that paper comes in many forms, each of which will produce different effects when wet:

- coffee filters
- paper towels or napkins
- tracing paper
- tissue paper
- poster board, matte board, or cardboard
- wax paper
- watercolor paper
- three-dimensional paper such as paper towel rolls, milk cartons, or boxes

And of course, soaking often leads to ripping!

PROJECT

Wax Resist: An Early Multistep Project

Painter and visual artist Alexis Manheim helped develop this project. It makes ideal use of children's interest in texture and color, and it also provides a sequence that inspires observation and evolving awareness of color. It uses two media—wax pastels and liquid watercolors—to illustrate the qualities of paper and paint in exciting ways.

WHAT YOU WILL NEED

- poster board, matte board, or another kind of sturdy but absorbent paper (I sometimes splurge on something really beautiful and fibrous from the art store!)

- a fresh box of inexpensive wax or oil pastels. Note: new pastels work best because they have not been coated by pigment from other colors and will produce clear, vibrant hues.

- several shades of liquid watercolor paints or food coloring

- large brushes, sponges, or rollers

Photo 3.18

HOW IT WORKS

The first part of the project focuses on exploring color with the wax pastels. As with other projects, you might like to start this long-term exploration with some "research." Children can be inspired by looking at reproductions of works by modern artists such as Wassily Kandinsky, Joan Miró, Willem de Kooning, and Robert Rauschenberg. (Alexis Manheim often shows my class photos of herself at work with her daughter in her studio—the connection to the artist is very evocative for the group.)

The project is simple to set up. Just make the pastels available at the art table or area with one or two large pieces of poster board or other surface. The pastels are ideal for open-ended exploration, since they can mix together and retain their original hue. Some shades, such as yellow and red, will layer over each other and form a composite color, but this effect is subtle. You can also offer clear wax, which leaves no trace until the paint is added.

Photo 3.19

Photo 3.20

Because of their shape, pastels, like chalk, present several unique motor opportunities. They can be used like a pencil to make lines, dots, and curves, or they can be laid on their side to create large fields of color and shape. Children find this proposition particularly joyous since it invites them to tear the paper off of the pastels. (These can be saved for collages.)

You may want to have teachers and family members join the children during these early explorations to observe and extend the children's discoveries. While respecting the abstract nature of the project and avoiding drawing or writing in an adult manner, adults can freely mimic, extend, and expand on what the children are doing and sometimes suggest strategies like laying the pastels on their side.

Photo 3.21

The key to this part of the activity— what elevates it above simply drawing with crayons—is to return to the paper and the pastels over several sessions. If you prefer, you can begin with monotones or earth tones and go on to explore primary and then composite shades, or the opposite. Children will find plenty of value from exploring with pastels over time regardless of how you organize color. As they add layers to their previous work, the interplay of old color and new sparks their memories and presents a model of sequential work.

You can also use large pieces of paraffin wax to provide a different texture. These will allow large, clear scratches and preserve some of the color below.

When the children seem to have reached a limit to their curiosity, it is time to move on to the next stage of the project. Now introduce various shades of watercolors and differing tools over several sessions. The wax resists the watercolors, creating a batik-like effect.

Different combinations of tools will promote unique chances for observation as well as effects. You might start with small- to medium-sized brushes, which make delicate and defined lines over the lines of the pastel. Then you can go on to offer bigger brushes, sponges, or rollers: small corners or windows of these paint lines will remain uncovered and vary the texture.

During this part of the activity, it becomes important to think carefully about color. Unlike the pastels, watercolors can easily merge to form grayish browns, which, besides being aesthetically unpleasing to adults, reduces the children's opportunities for observing the relationship between the two media.

Photo 3.22

Photo 3.23

Photo 3.24

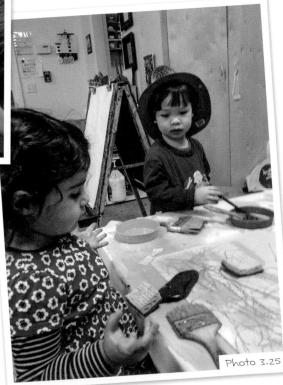

Photo 3.25

The goal is to help the colors pop from the background to represent the children's exploration and excitement clearly and effectively. And since you can offer paints over several sessions, it makes sense to offer only one or two complementary colors at once.

Furthermore, since the base layer of pastels will inevitably feature a rainbow of vibrant hues, using more muted tones of watercolors will emphasize the contrast. Shades of slate blue, tobacco, olive green, or even a light gray will soak into the paper and create an exciting contrast with the colors underneath.

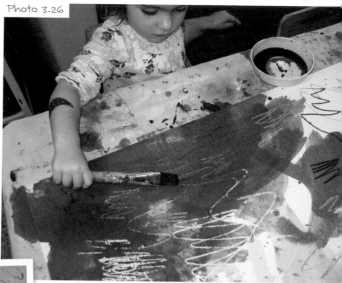

Photo 3.26

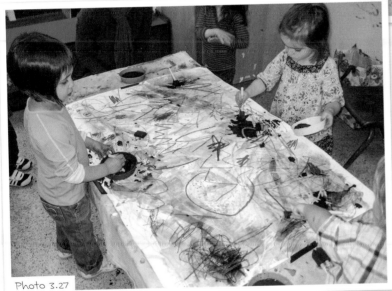

Photo 3.27

When helping children build layers of paint, remember to use lighter colors first, then darker colors. Start the watercolor stage with a highly diluted yellow, for example, and move on to blue or green. Keep in mind that the red-orange spectrum and the blue-green spectrum can interact in volatile ways.

Ultimately, as with all the projects in this book, it is the exploration and discovery process that matters. If children are motivated to mix colors that create soot gray or dirt brown, they (and perhaps you) will still learn from the process. This project can always be repeated since it is so simple and inexpensive. Reflecting on what you might do differently, or simply on what children notice in the first study, in some ways offers more learning about color than a carefully controlled palette.

Even mopping up puddles of paint with paper towels extends the interest in the project. As Eleanor Duckworth (2006) describes in her essay on Piaget and learning, "The Having of Wonderful Ideas," children must be able to try their shoes on the wrong feet in order to learn where they go.

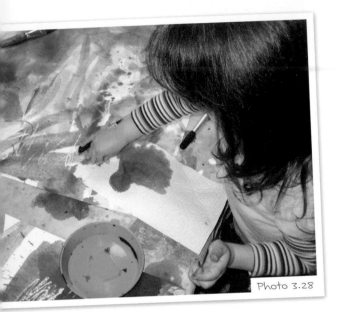

Photo 3.28

As with all projects, children respond well to exploring aspects of the artwork in other realms. Books on color and painting, such as Ellen Stoll Walsh's (1995) *Mouse Paint*, will prove particularly interesting during projects such as these. Toddlers in my program have shown a fondness for Margaret Wise Brown's (1958, 3) classic *The Color Kittens*, where, on one page, the kittens mix several colors to create "brown like an old goat." This phrase became a buzzword for color experiments throughout the year.

When Alexis first partnered on this project at The Little School, we asked her to sit at the art table and work with the children. We noticed that she spent much of the first hour in awkward solitude. But somehow the paper kept becoming busier and busier with children's work!

Toddlers, especially in a classroom with many choices, have a unique way of working. They rush the art table when they first arrive and then drift off to dress up or build with blocks. Two or three children will wander by the art table, barely attracting notice as they scribble. And then two minutes before cleanup time, a group of children will gleefully put in some intent effort, chatting and circling the table.

The role of the adult in this rhythm can be hard to keep in focus. Toddlers often thrive when no one is watching or leading, but they also like to partner with adults. This is an ideal opportunity for you to help peers connect with each other and to foster habits of thinking and working.

You also have a great opportunity to use both your presence and your distance to help very young children visit and revisit art projects, even for just moments at a time. Leaving lots of time for open exploration and cultivating a relaxed but available attitude are key to helping toddlers engage with art projects.

Documentation

The Wax Resist Project is ideal for sharing with the school community. Photographs capture not just the moving evolution of color and layers but also the children's deep engagement and observation; fostering observation is the project's main

focus. The photographs also illustrate for children an early finished work, which rarely fails to surprise and inspire them as well as older children and adults. Consider sharing pictures of the different stages of the project, along with the children's words and the teachers' explanations, informally through a blog or on a bulletin board. You might also have children and visitors look at pictures of the work on the classroom computer.

When the work is finished, be sure to display it, along with a description of the project, in a place where everyone can see it. Consider creating a slide show that could run on the classroom computer next to the finished work. As always, documentation here should be primarily focused on extending the children's observation, thinking, and exploration. It should also deepen the teachers' understanding of who is engaging with the project in what ways and connect a group learning process to the surrounding school community.

Gluing Projects: Variations on a Reggio Classic

PROJECT

In *The Hundred Languages of Children*, Rebecca Kantor and Kimberlee L. Whaley (1998) describe an inquiry-based series of explorations with glue in an infant-toddler class. Their brief account lays out many features of a project-based approach to art with very young children:

Photo 3.29

- exploring the qualities and suggestions of individual materials

- allowing children to engage simply with a material over time before introducing or suggesting variations or additions

- using observations, documentation, and discussion to decide how to proceed

- provoking sequential exploration in an open-ended way

- introducing new materials gradually

- documenting and recording the children's exploration and ideas through photographs and dictation

Horizontal and Vertical Value in Toddler Learning

Exploring materials over time before using them to assemble finished products is an example of what is sometimes called *horizontal* learning. Horizontal learning is just what it suggests: extending exploration of one thing across time and learning domains, with emphasis on discovery. It is distinct from *vertical* values in education: acquiring skills or knowledge to move up to the next level of learning in an effort to reach the highest level.

Project-based education and developmentally appropriate toddler curriculum both emphasize the importance of horizontal value. Infants, toddlers, and young preschoolers need time, repetition, and variation to develop habits of learning. They develop abstract thinking and planning skills out of concrete experience.

Art is, of course, loaded with horizontal value. It invites us to slow down, observe, revisit, cover up, add layers and detail, and enjoy sensorimotor experience. But as with any contrasts in development and learning, horizontal value and vertical value are not really separate. It is by focusing on the moment and the process that children find the tools and means to create a project and learn new skills.

WHAT YOU WILL NEED

- a large sheet of butcher paper and masking tape (for tabletop)
- bottles of white glue
- various containers, such as bowls, spoons, and jars
- craft sticks
- pipe cleaners
- aluminum foil, cardboard, or other materials for gluing experiments

HOW IT WORKS

At The Little School, we have developed several projects that use this basic Reggio Emilia–inspired approach to glue as a jumping-off point. We have tried to extend or further explore some threads in more detail. Through observation of specific groups in our setting, we have also come up with threads of our own.

Kantor and Whaley (1998) began their project by putting plain white school glue directly on a paper-covered tabletop to invite exploration and discussion. This is a logical beginning: just white glue and a surface. Indeed, long after children are making full-blown collages, some children will still paint a masterpiece in white glue, only to find it invisible the next morning.

Containers are the first new material to appear, and here you can think creatively. The quantity of glue used at this stage can lead to many different experiences. Just a drop or two in the wells of a palette will inspire a different experience than if you offer soup bowls with a half cup of glue inside! These

early sessions establish an invitation to muck, dump, pour, and drip. So think in terms of how you will prepare the environment, how you will inform families in advance, and how much of each material you will provide. Also determine when and how you will clean up and move on each day.

Consider varying motor challenges and opportunities when choosing containers and tools. Glue at the bottom of a test tube, for example, sets up a fine-motor challenge. Craft sticks, pipe cleaners, or watercolor brushes might solve it, but perhaps not right away. A tray covered with glue will guide fingers and palms along in broad streaks and strokes.

Observe what properties of the glue seem to attract the most attention. Some children are fascinated by glue's tendency to run and drip. This can lead to experiments with gravity. A slanted surface on the table (or even a temporary use of marble runways) invites children to explore further. Other children are more focused on peeling dry glue off of their skin or pulling previously glued elements apart. These explorations can be extended through materials as well, such as painting balloons with glue.

Even more than paint, working with glue calls for steps. After all, glue is usually used to attach one thing to another or to assemble many layers or pieces. And repetition and observation are core developmental themes of toddlerhood, as well as key elements of scaffolding projects. So when you invite children to explore just glue on a tabletop, try a few different surfaces with different qualities: slippery oil cloth, resilient cardboard, even foil or plastic wrap. And of course, a butcher-paper cover on the art table is a staple.

Whenever possible, save these surfaces and present them to the children to use again. This way, they will have a chance to observe the qualities and properties of dried glue and to explore the pieces that have stuck together before. They can also pull glued elements apart; you can encourage this activity unless the group has negotiated a different direction.

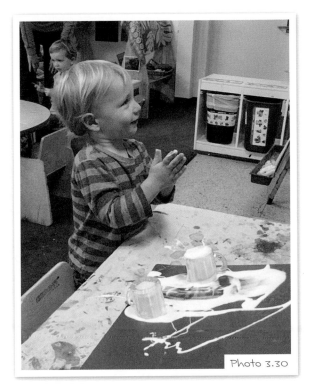

Photo 3.30

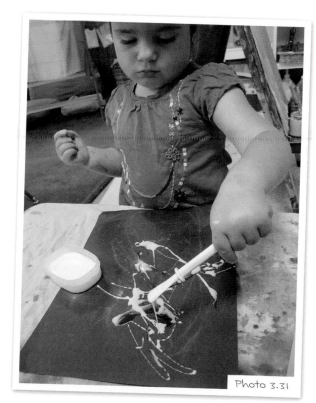

Photo 3.31

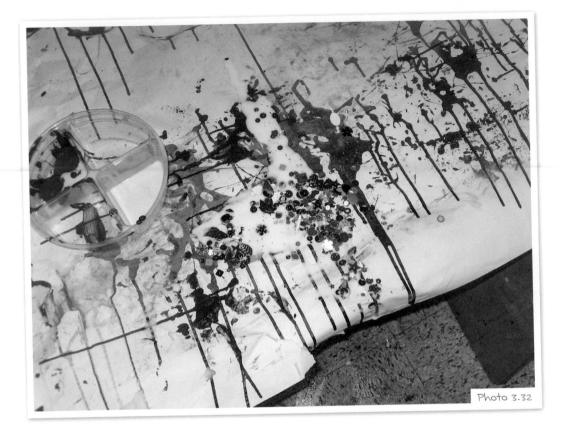

Photo 3.32

Help children experiment with the concepts of background and foreground by cutting up pieces of earlier work and offering them as elements to glue onto a new background. This is one of many ways you can help create little windows into larger works; in this case the window is made up of positive rather than negative space. Regardless of the direction you take with this idea, it will help children become more sensitized to the wonder of texture and color and expose children to some of their natural interplay.

Keep in mind that the brain develops via the limbic system during the toddler years. Imagination emerges from the limbic system's making sense of emotion. It forms a bridge to the abstract reasoning of the cortex. So you always want to foster the connections among sensory exploration, emotional learning, imagination, and cognition.

The sensory exploration of glue, even by itself, can lead to imaginative and emotional expression. Many children will liken the glue to lotion, which seems to heighten their surprise when it dries like tight plastic on their hands! Some will pretend they are making gloves. And, when inviting children to spill liquid on a table, we can mobilize humor and affect by playacting how adults usually respond to spills. Children can pour small amounts of glue from little bottles,

such as those for candy sprinkles, while adults cry out playfully, "Don't spill your milk!" The book *It Looked Like Spilt Milk* (Shaw [1947] 1988) is one of many stories you can use around glue exploration to further link texture and imagination.

When gooey and messy materials are offered over time, teachers can't help but observe how different children respond. Tactilely sensitive or avoidant children will often show interest or preoccupation but also anxiety and resistance. Again, emotional processing and dramatic play are good ways to help these children become more receptive to new sensations and experiences. For example, you can model feeling hesitant, using facial expressions and gestures, and then touch the glue with just your fingertips, showing relief or curiosity. Or you can use finger puppets to playact different processes and experiences from throughout the program at reading, snack, or meeting times.

EXPLORING COLOR, TEXTURE, AND TOOLS

After the children seem to have reached a plateau working with glue on various surfaces, it is time to introduce a new element. This is part of the process of leading children to the discovery of collage—putting pieces together purposefully. But you want to do this without rushing the sequence or emphasizing "correct" methods or formulas. A recommended first step is color variation.

One of the most basic color variations you can offer is clear glue, which you can order from any supply catalog.

Photo 3.33

Liquid watercolor or food coloring makes for evocative mixing and spreading, especially if you're using some backgrounds with earlier work on them. Children can spend many days mixing and moving glue and powdered paints. As they begin to notice the transformation of glue from opaque to clear, alternating white glue and clear glue can extend their thinking. If you add only a few drops or grains of color to a small container of glue, children can observe dramatic changes as they blend the color in.

At this point, the children's interest in color often inspires me to start offering the glue in containers with sticks and spoons to make it easy to move around and pour. Mixing color adds tools to the process without adding steps.

Another learning value of glue is the interplay of sticky and slippery. Early childhood programs typically offer children materials that are slippery and not sticky: shaving cream, dish soap, or hand soap, for example. But children also like to spend time exploring materials that are sticky without being slippery, like tape. As they try the glue, some side projects can help extend their thinking about different sticky media and how they might be put to use.

A large strip of contact paper is perfect. It fits the open-ended discovery nature of toddler exploration. Making things stick to contact paper does not require fine-motor strength or dexterity like tape does, or a sense of sequence like glue or glue sticks do. So children can use it to begin collage work easily. And because contact paper is not very sticky, they can deconstruct with abandon as well.

Favorite materials to offer with contact paper include these items:

- tissue paper

- colored cellophane or similar clear material

- feathers

- pom-poms

- leaves

- dried flowers

- colored powder

- construction paper scraps

- sand

- buttons

Because contact paper is easy to move around, you might start a collage on the tabletop but then pin the contact paper to the wall for a few sessions to give the children a different view and new movement opportunities.

The contact paper project can serve as one of the first finished collage works in a toddler class. Consider displaying it with photos documenting the process and an explanation of what an important step it is in the children's artistic development. Invite families to look at the installation with their children, who will discover how gratifying it can be to display work to an audience. From there, they will often show a hunger to create more work.

Children often need to experiment for some time before they discover the order of (1) background, (2) glue, and (3) object. They frequently pile elements together with glue and learn that because they do not use enough glue or put it in the right place, the pieces do not stick together. One collage project that is guaranteed to hold together features tissue paper and liquid starch. As the starch saturates the thin paper, it holds several pieces together or onto a surface regardless of where a child applies what. The starch also transports color from the paper, so that even if children remove the paper, they will create patterns and shades.

Small printers' rollers are an ideal tool for this project, since the tissue paper sticks and comes loose frequently. The rollers move the whole collage around in unpredictable ways. And this always provokes observation and discussion. The paper wads up into pieces of different thickness, creating a spontaneous depth to many creations.

Tissue paper is so malleable when wet that this project lends itself beautifully to three-dimensional or textured surfaces. Try having the children cover a small pumpkin (a good fall project) or hard-boiled eggs (a good spring project) using tissue paper and liquid starch. As the children peel the dried paper off the pumpkin or eggs, they leave a unique patchwork color scheme.

One group of two-year-olds I worked with became interested in rainbows after two children brought several vials of brilliantly colored earth to class. They used prisms, cameras, colored blocks, and several other tools to think and work together. Then the group discovered that liquid starch caused a thin rectangle of poster board to spontaneously curl up like a rainbow, which the children then colored.

Adding a Second Element

One of the most inspiring detailed practices to come from Kantor and Whaley (1998) was the idea of putting solid objects into the glue in order to promote the next step toward collage. Their project, in many ways, provoked my thinking about all the ideas in this book. It takes an open-ended, sensory exploration and stretches it by one step. This addition suggests many useful basic outcomes and perspectives but also still leaves room for multiple avenues and modes of exploration. It points to detailed strategies but does not dictate a right or wrong way or a unified finished product.

Photo 3.34

Photo 3.35

Children often spend significant and purposeful time and energy putting more and more small objects into the glue. With spoons or craft sticks, they mix and stir and load until someone has the urge to dump the entire container or the ever-growing pile of glue and objects spills over the top. This is a perfect example of how sensory-based exploration and observation can lead to a deeper understanding of sequences and organization. It is also a reminder to think of cleanup time as part of the creative process, since that is when you often have to decide where and how to dump out your glue experiments. Keep the work nearby in case cleanup provides an opportunity to revisit and add to the work with new colors or objects.

USING CULTURAL TRADITIONS TO FOSTER EXPLORATION

Project-based art education builds its curriculum mostly based on children's thinking, exploring, and inquiring. It can seem opposed to a certain traditional approach of teachers helping children to make beautiful things for a defined purpose, such as puppets or Christmas ornaments. Likewise, the idea of organizing art projects around a preconceived adult product that each child will make can be seen as counter to many of the goals of project-based art education.

Nevertheless, there are strong threads within the project curriculum—most prominently in the Reggio Emilia literature—for project-based inquiry to grow out of the real interests and culture of each individual school and its surrounding community (Malaguzzi 1998). Children are interested in holidays, media, sports, and other cultural activities and forces, which can then be the basis of emerging inquiry.

I can still remember how much it meant for my toddler son to present me with a Christmas tree ornament that bore his picture (and no sign of his own handiwork!), and after fifteen years, I still proudly hang it on my tree each year.

So teachers need not get bogged down in a simple view of *good* or *bad* inquiry when it comes to the cultural tools available to us. Cultural rituals and shared products, like gifts, lend themselves to effective project learning just as much as natural themes such as rain or shadows. The following projects offer opportunities for exploration of shared cultural experiences.

Snips

At a time when conserving resources has become an educational unit even for toddlers, art can play an important role in helping children learn to appreciate unusual qualities in materials and to develop a creative eye for reusing what they might otherwise call garbage.

One small example is saving the bits of construction paper that are left over from other explorations. My colleague Jetta Jacobson would keep these scraps in a special basket and call them "snips." Whenever a collage project developed, the snips basket was there to be used. These scraps help form a sequence of uses for one piece of paper and help children understand the art area and its different functions.

Snips, and other reclaimed trash, can be used in the glue projects described in this chapter and work particularly well with the contact-paper collage.

PROJECT

Birthday Crowns: Using Cultural Traditions as Inquiry Projects

In North American culture a birthday is often a child's day to be the center of attention. One way to celebrate birthdays in child care is by making the birthday child a construction paper crown.

The birthday crown is both a prop—a teacher-made product to have, wear, and photograph—and a keepsake. The crown heightens the child's sense of special status and emphasizes the special occasion; it's important on a personal level. But it is also a teacher-led project with clearly defined steps and sequences and lots of structure. In other words, it uses the incentive of the finished product to define and stretch a toddler's engagement with organized, goal-oriented work. It also offers toddlers multiple opportunities for open-ended process, initiative, variation, and, of course, sensory explorations.

Photo 3.36

WHAT YOU WILL NEED

- adult scissors
- a large bottle of "tacky glue"
- small bottles of glue (half-filled)
- staplers
- staples
- small shaker bottles of glitter
- construction paper
- birthday candles

You may wish to keep all the materials for birthday crowns in a designated birthday-crown box. (In addition, when you start this project, you may also want to supply child-friendly scissors, as well as colored construction paper.) Beyond its convenience, the box balances teacher structure and child opportunity for an entire year of birthday crowns and beyond.

HOW IT WORKS

From the first moment you take the box out, present it as a box of teacher tools that just the teacher opens and uses. This not only frames the project and addresses safety issues around scissors and staplers, but also high-lights each tool so that it becomes a landmark in a sequence of steps.

Photo 3.37

First, ask the birthday child to choose her paper colors. You will need six standard sheets of construction paper to make a crown that will wrap all the way around a child's head. As you help the child decide how many different colors she wants in her crown, your conversation will lead naturally to an exploration of fractions ("You want three colors, and we need six sheets. Let's count how many sheets of each color we need").

Photo 3.38

Other children will want crowns of their own. This presents many chances to explore concepts of democracy and individualism. Explain that the teacher makes each child a crown on his birthday, but children are welcome to make their own crowns and help with the teacher-structured crown as well. Show the other children the child-safe scissors and small bottles of glue they can use if they want to make crowns. Many children will be inspired to pick out their own paper and organize their own materials.

Next, review the limits around the birthday-crown box, and take out the adult scissors. Invite the birthday child to choose a shape for you to (attempt to) cut at the top of each point of the crown. Stack the sheets of paper together and cut them—remember that you don't need great fine-motor skills! Failing to make a star or dinosaur shape can be just as valuable as nailing one. Surprise or even failure is part of the process, and you have a golden opportunity to use your own challenges to model curiosity and a relaxed reaction to the results.

Staplers are one of two methods used in the project to attach separate sheets of paper, so this step offers all kinds of learning opportunities. Overlap two sheets at a time and staple them just once to hold them together. After stapling a few sheets, invite children to try the stapler. The visual-motor process of pushing a staple out of the stapler contains all kinds of sensorimotor learning. You can help children discover how putting one hand over the other, balancing the ball of the hand on the very front of the stapler, and pushing hard enough to feel two clicks of the stapler are all necessary for success.

Continue to support the children's ideas and variations as you go along. Many children will undertake their own cutting during this part of the project. The table tends to pile up with snips, which children will incorporate into their experiments. By the time the stapler arrives, many children will have made interesting piles or arrangements of whole sheets of paper, scraps, or both. The stapler can be an ideal tool for experimenting with connecting these "collages." Once you have finished overlapping sheets and stapling them to form the birthday child's crown, take a moment to help the other children staple their own creations.

Pass out the small bottles of glue to those children who want to move on—but make sure everyone has put away their scissors first! Consider filling up the

glue bottles halfway so the children can squeeze out glue freely but only up to a point. Use the large bottle of tacky glue to write the child's name and age on the crown; you may also wish to add some extra glue decorations.

While the small bottles of glue are available to reduce the amount of waiting and turn taking necessary in such a teacher-intensive experience, you can also give any child who wants a chance to squeeze out some of the adult glue from the large bottle. The big bottle of thick glue offers a wonderful proprioceptive challenge, and children seem to get great satisfaction both from the physical exertion and from the thrill of using a grown-up tool.

Photo 3.39

Finally, offer the small bottles of glitter. I recommend taping the lids shut to encourage children to shake rather than pour out great piles of glitter. Occasionally, however, children will find a way to remove the cap and follow their natural urges. That's the reason you fill the bottles only halfway.

Invite the children to shake some glitter on the big crown, but also encourage their own ideas. You will notice that some children will pick up on the conventional sequence of laying down a base of glue and then adding glitter. Many children, however, will simply paint or draw or explore with glue alone, or they will pour glitter straight onto their paper with no glue to hold it down.

The key at this point is to focus on your work with the glitter on the birthday child's crown. Even if few or no children express interest in adding glitter to the crown, you might still ask for their help—for instance, to check if all the visible areas of white glue have been covered or to ask what color glitter should be used next.

Take a moment to observe and discuss what some of the other children have tried. For example, when a child adds lots of glitter to a piece of paper with no glue, you might initiate speculation among the group for what will happen to the glitter when the paper is moved, or even invite an artist to turn her paper over to see if it sticks. As always, balance these conversations with a focus on the main project.

When the children have had ample time to experiment with glitter, and when they feel enough glitter has been added to the birthday crown, lift the crown and roll the loose glitter from side to side. You can sing a variation of the song

Photo 3.40

"Shake Your Sillies Out" ("Shake Your Glitter Out") to mark this step. Then slide the remaining loose glitter into a bowl so you can return it to the small bottles. (Be sure to enlist the children to help you put the glitter away.)

The final element of the project revolves around how glue's sensory properties change over time and around paper's amazing potential to go from two to three dimensions. Ask the children, "Do we put it on the birthday girl's head like this, when it's flat?" This leads to exploring how you can use the stapler to make it into a cylinder that fits just right. But not yet! "Can we put the crown on now?" you might ask next. "What will happen?"

Children tend to delight in this part. After all, waiting for a special prize is such an integral part of the birthday experience that even toddlers seem to appreciate the value of putting the crown up for a short time to let it dry. Once it's ready, present the crown, staple it closed, and crown the birthday king or queen with great fanfare.

The Lei See Project: Parts to a Whole

I teach in San Francisco, where Lunar New Year is a significant event, and it is becoming part of our country's cultural fabric. It's a chance to observe and support many different levels of tradition and exploration. For some families who have celebrated Lunar New Year for generations, it is a time of familiarity and repetition. For children whose families have arrived in the United States during their lifetimes, the celebration acts as a bridge between roots and a new community. For other children, it is an excursion into foreign images, sounds, tastes, and rituals. In San Francisco, there is a large population of people with Chinese heritage. This project could be adapted to reflect the cultures in your particular city or region. It can even be done with greeting cards and wrapping paper.

Photo 3.41

Many Lunar New Year projects for children turn on the idea of making a souvenir. Perhaps the most common is the egg-carton dragon. Lunar New Year revolves around iconic objects such as lions, firecrackers, and banners, as well as gifts.

With toddlers, however, the end point is less important than the journey—although children should be invited to make a few meaningful and satisfying stops. So rather than construct a gift or keepsake, consider following a sequence of "deconstructing" common objects and providing materials and space to "reconstruct" them as an assemblage of elements.

Specifically, you can use banners and *lei see*—the Cantonese term for the little red envelopes that typically contain real or chocolate money—as ingredients for a collage. You will reinforce some of the basic guidelines of gluing: reusing materials and repeating the exploration over time with subtle variations. But you'll also introduce a few new values: using familiar images and words as a flexible model and using art as the hub for multiple cultural explorations. You can then blend these with concepts of family and ethnicity, city and community, sounds, smells, tastes, games, and so forth.

WHAT YOU WILL NEED

- red, gold, or other subtle shade of butcher paper
- scissors
- thin paintbrushes
- dark watercolor or tempera paints
- a package of *lei see* envelopes
- about twelve Lunar New Year posters, banners, signs, or other decorations
- glue spreaders
- small, shallow containers for glue

HOW IT WORKS

You'll begin this project away from the art table: reading books about the Lunar New Year, decorating the classroom, and doing "lion dancing." I recommend the book *Lion Dancer* by Kate Waters and Madeline Slovenz-Low (1990) (see the Lion Head Project in chapter 5). At The Little School, we have a communal celebration with real lion dancers, and families often tell their personal stories of Lunar New Year. So by the time we begin exploring with art, the classroom and school are typically suffused with the holiday.

Begin by offering the children the *lei see* envelopes and scraps of paper. Some children may begin with the idea of filling a *lei see* with "money" that they create themselves. Others might explore the delicately illustrated envelopes, tearing them open or attempting to cut them in half. It is important to give the children lots of chances to engage with the images and text on the decorations. This will be an early chance to think about taking symbols apart and incorporating them into one's own construction.

As you accumulate pieces of paper, collect them in a clearly labeled basket. After the children have explored the text and images from Lunar New Year for several sessions, provide larger pieces of blank red paper, roughly in the shape of the banners and *lei see*, with black and gold paint and thin brushes.

Cover the table with red paper (or red wrapping paper with black Chinese or other characters), so the children will be free to pursue any idea. The shapes simply frame an invitation to represent what they have been seeing in and out of the classroom.

This stage may occupy groups of toddlers for several sessions or run its course quickly. As you observe an appetite for further exploration, you can put the paints and brushes away and return the scissors so that children can deconstruct or

reconfigure their own original work. You might also hang the children's banners next to the commercial versions.

With this fieldwork and study phase complete, return the same butcher paper to the table—now covered with paint—along with the baskets of snips, any larger work the children have created, small shallow containers of glue and sticks, and spoons or spreading paddles.

As with earlier projects, some children will be drawn to the glue and focus on stirring it with their hands, dripping it from up high, or dumping it on the table.

Photo 3.42

Others will no doubt fill the glue cups with scraps. Some will spread glue on smaller pieces of paper.

And some will, gradually or all at once, discover how small pieces can be covered in glue and stick to the background—in intriguing patterns.

Photo 3.43

Photo 3.44

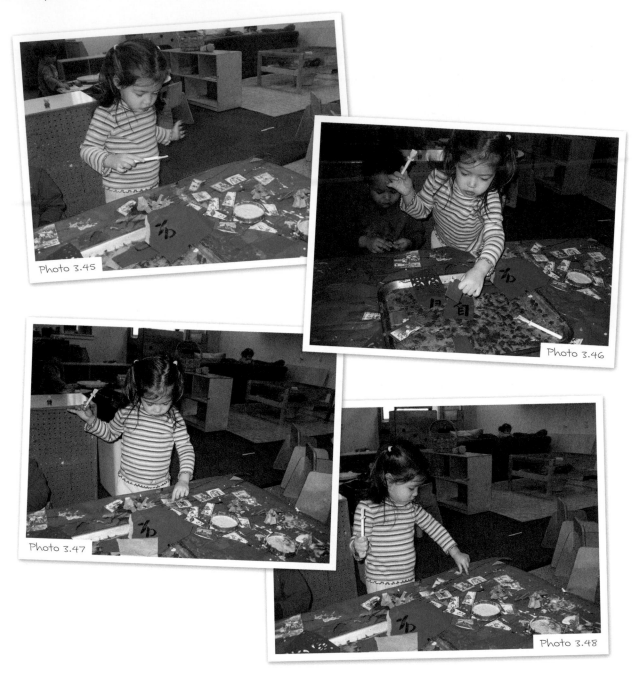

Photo 3.45

Photo 3.46

Photo 3.47

Photo 3.48

But a child need not achieve this all alone. This project illustrates how different learners at different times can contribute to the same project. Those who like the feel of glue will leave the butcher paper sticky and ready for more pieces. Those who dump the glue or the paper basket will put elements together. Those who like to sift the snips for favorite colors or their past work will sort and organize. And those who like to observe and arrange will help create patterns and coherence. But it all comes together in a pattern that no one can predict.

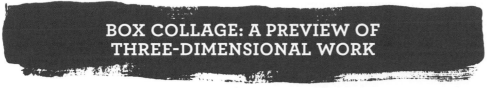

BOX COLLAGE: A PREVIEW OF THREE-DIMENSIONAL WORK

One spring at The Little School, when we had been exploring glue with our two-year-olds for several weeks, a family brought a sandwich to a potluck in an elegant, shallow wooden box. Seeing an opportunity (and hating to throw away a sturdy container!), we kept the box and introduced it to the class at the art table.

It proved to be a perfect way to suggest depth to toddlers without taxing their fine-motor or representational skills. At first the children simply poured glue into the box. Even when they would almost fill it with wet glue, the box would reclaim some empty space by the next day. We gave the children powdered and liquid colors to mix—they made an intense swirling effect in the dried glue.

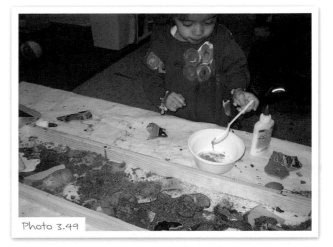

Photo 3.49

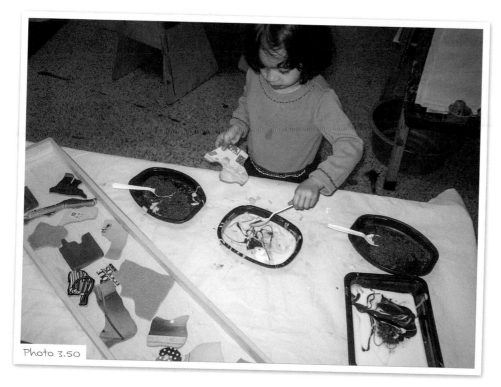

Photo 3.50

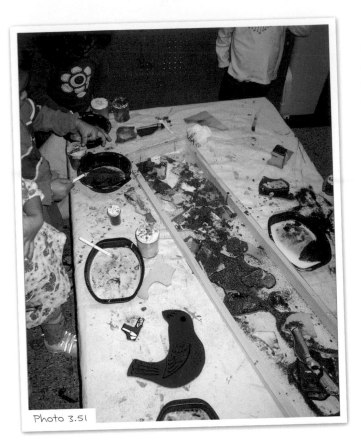

Photo 3.51

We made the lucky discovery at that point of a bin of mismatched puzzle pieces in our art cabinet. These matched the size and depth of the box perfectly. Children could glue them together without putting them in the box, or dump them in the box along with the glue to make piles and stacks. The patterns on the pieces mixed with the colors in the glue to extend the children's observation and discovery. We have since used photographs from magazines, discarded figurines, blocks, and calendar pages—just about anything someone was prepared to throw out. Because the project was inspired by repurposed trash, it seemed to naturally reflect on art as a way of reconceiving the value of objects in our culture.

Although we did not set out to introduce three-dimensional work to children this young, this accidental project reminded us that there are always ways to present diverse opportunities to children of any age.

CHAPTER SUMMARY

In this chapter, you read about how toddlers use sensory exploration to begin making sense of and mastering their new environment and experience through the creation of collages. With these early collages, we see the emergence of planning, collaboration, negotiation, steps, abstract thinking, and combining elements to create something new. Chapter 4 will explore how a long-term group project can help toddlers apply these habits together in one big work as they mature into young preschoolers.

Discovering Sequences and Symbols

The projects described in the previous chapter focus on meeting younger toddlers' natural desire to explore sensory or emotional experiences in the moment. It presented simple ways to suggest steps, end points, and symbolic representation.

As children approach age three and older, their thinking and exploration begin to move in these directions on their own. Their thinking becomes more symbolic, enabling them not just to try to express specific ideas and images but also to make a plan for expressing them. Children at this age become more socially and culturally attuned,

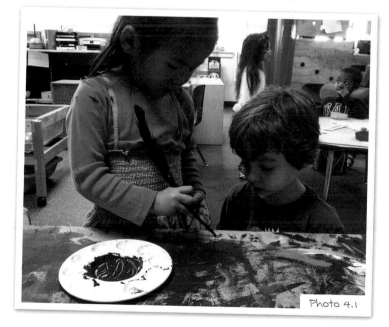

Photo 4.1

and they begin to explore their place in a group and in the larger world. In other words, they begin to work from their imaginations and social connections.

This chapter describes one long project that focuses on how details emerge from the big picture. It is designed to bring a group of children together, as they mature from solitary explorers to team players and as their attention to and ability with fine-motor expression, representational drawing, and other details takes off.

PROJECT

The Canvas Project: A Yearlong Introduction to Projects

The Canvas Project is one of the most exciting of the ongoing toddler art experiences in my classroom—and also one of the oldest. Somewhere around the Bay Area, there are now fifteen finished canvases hanging in schools and homes. My colleagues and I have talked of hosting a canvas exhibit at a local gallery or the school. We would invite all the students who have participated in the project (who now range in age from three to nineteen) to attend as the artists of honor. In many respects, the very idea of a project approach to art curriculum—and this book—grew out of the Canvas Project. It brings all the major themes and goals of this book together:

- Each step is completely open-ended and flexible.

- It becomes a project and a finished work as children mature and engage repetitively.

- Different kinds of learners can find different ways to connect and contribute.

- It naturally incorporates discussion, planning, and negotiation, guided by the children's levels of development and styles of exploration.

- It encourages gross- and fine-motor expression.

- It attracts many children who do not often show interest in art.

- It encourages relationship building and group work.

- It encourages planning and reflection over time.

- It inspires children to work on long-term projects because of its important place in the classroom.

The idea came to me one day when I was fixing our classroom easel. As I tightened the screws, with my face just a few inches from the work surface, I was struck by all the accumulated layers of paint around the border. It made for a very moving effect: great peaks and rivulets of green, purple, and yellow rising an inch from the smooth foundation. The vividness of the textures and colors communicated so much energy, curiosity, and effort over time. It was a work of art! And yet it had been created haphazardly, without any kind of idea or plan.

I had one of those lightbulb moments, where something that I had not noticed before suddenly seemed obvious. Even very young children create sustained,

purposeful processes of inquiry simply through repetition. Each step can look like a brief and disorganized pit stop for sensory dabbling or a passing means of resolving a tearful good-bye. We may not notice, but over time young children can engage with the product of their exploration in meaningful ways.

The results of their open-ended processes can teach them about conceptualizing an end point. Pure abstraction can promote representation. Uncoordinated pieces can add up to a coherent whole. The key is to offer it as a regular class project over a significant period of time and elevate it in significance by using special tools and materials.

Fifteen years later, the Canvas Project continues to be embraced by

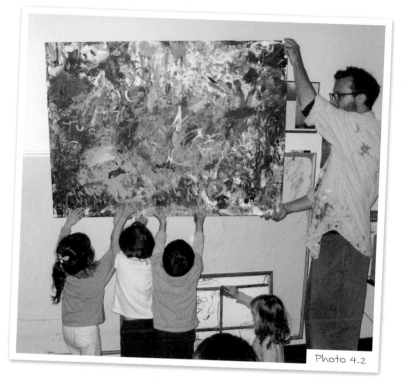

Photo 4.2

our three-year-old classes from fall to spring. It forms the backbone of our art curriculum. Besides what it offers the children, it helps participating families recognize and celebrate the developmental leaps of toddlerhood. More than anything else, the project serves to show toddlers just how much they can accomplish themselves with minimal teamwork and small bursts of activity. It acts as an effective blueprint for all sorts of project work.

Because this is such an important part of our curriculum with toddlers, we think carefully about how and when to present it. In our classroom, we like to invite children to arrive early and, with their families, help us prepare the classroom materials. The Canvas Project is a transitional, welcoming activity at the start of the morning. We usually gather the tools and paints we will need beforehand and prepare the canvas if necessary. We also take care to prepare any other classroom materials or environments in advance so that we won't be too distracted at the start of school. (It helps if teachers take turns being in charge of the canvas, alternating with other tasks.)

As children and families arrive, we enlist the children to help squeeze the paint onto the trays or into the palettes, get water from the sink, or do other simple set-up tasks. Family members with a little extra time often take photographs with our classroom camera.

The canvas acts as a magnet for children at the start of the day. The excitement of working with teachers and peers often helps children through a hard good-bye or two (three-year-olds are still actively mastering separation). Holding up the tools of the day, those who have arrived early often call out excitedly to their friends who come later.

A pattern that will be common for the duration of the project is established: a burst of high interest and affect at the very start of the morning—children laughing and talking as they paint with animation; then a quiet period, when individuals, pairs, or trios stop by for a few minutes; then another burst of interest an hour or so later, just before we clean up and hang the canvas on the wall again.

Just as the project in general helps provide a subtle organizing structure to the open, play-based classroom, it also supports an organized and regulated flow of events each day: children separate from their families, greet friends, choose from an array of activities, and engage naturally and repetitively in sustained exploration; teachers partner with children throughout the day, fostering their learning opportunities, and also keep families connected to and involved with the curriculum.

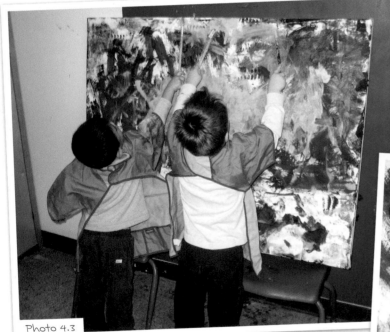

Photo 4.3

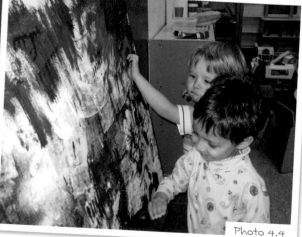

Photo 4.4

WHAT YOU WILL NEED

The key to the Canvas Project is simplicity—
it uses very ordinary materials. The focus
is on exploring tools and art media. You
will want to assemble a large repertoire
of painting tools:

- a large, prestretched, gessoed artist's
 canvas (available at art stores)

- a selection of acrylic or tempera
 paints (see page 76 for information
 on these paints)

- drop cloths

- a classroom camera

- large rollers

- small rollers

- squeegees

- flyswatters

- paintbrushes of all sizes and
 shapes and with varying grips—
 from wide house-painting styles
 to watercolor brushes

- wooden dowels of different
 lengths

- sponges

- golf balls, Ping-Pong balls,
 Koosh balls, bumble balls, and other balls of good size,
 weight, and shape for fine-motor use

- toothbrushes

- natural items such as twigs, blooms, stems, feathers, and leaves

- spoons

- cotton swabs

- eyedroppers

- toothpicks

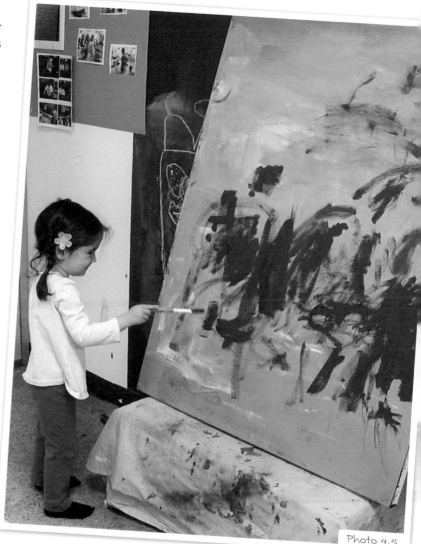

Photo 4.5

HOW IT WORKS

Each summer, the toddler teachers take a trip to the art store without children. This step may seem obvious, but it is all-important. As I pointed out earlier, it is helpful to build long-term excitement and curiosity about art materials and the role that art plays in the community. Teachers should communicate that the activity or project is a special opportunity for children. And when, in the first moments of each session the teacher excitedly brings out a new tube of "grown-up" paint, the children's emerging passion for commodities becomes associated with the creative process.

It is important for the adults to have an authentically passionate relationship with the art store. This is not difficult, at least not for me! Each time I visit the store to prepare for a year's worth of art projects, I get genuinely excited. First, I go straight to the materials I will need—the least expensive tubes of basic acrylic color and the big stacks of canvases in the back. I can't help generating abstract images of my own of all the incredible discovery and fun the children will have with them.

As you can see, teacher passion is a way of linking, as Vygotsky (1978) suggested, past, present, and future collaborations with students. As you present a new paint or material to the children, you can describe where you found it in the art store. Your description creates an image of the art store in the children's minds. The image of the art store is also an effective subject for fostering abstract representation:

- It is a place away from school where you went at a different time.

- You have the artifacts, which will become more and more real and familiar over the months you use them.

- You can tell your story of visits to the art store, perhaps even using visual prompts like simple drawings or photographs.

If schedules permit, my coteacher and I take this trip together so that we can mobilize not just our individual enthusiasm, but begin to talk, plan, and brainstorm together.

You may choose to start this project with raw canvas from the fabric store (another exciting teacher resource) and enlist artist friends from the community to stretch it for you. This offers several exciting steps: you can show the children a folded piece of ordinary looking fabric to start, so that the transformation to a finished painting would be that much more illuminating and magical. You could also add the gesso layer (a primer for canvas) together, which tightens the canvas onto the stretcher like a drum. However, unlike acrylics, which are water-based and nontoxic, gesso is oil-based and gives off thick fumes.

Another way to begin the project is with a prestretched, gessoed canvas, which provides a flat, white background—perfect for the first session. Over the years, I have followed both ways of starting the project—with raw canvas and with prestretched canvas. I prefer using the prestretched canvas.

We follow some specific sequences with each class:

Photo 4.6

- Begin with the largest tools of the project, and progress down to the smallest (following gross- to fine-motor development).

- Start with monochromes (black and white), and move on to earth tones, then primary colors, and then all tones.

- Provide one color at a time for the first few sessions, and then invite the children to mix two or three carefully chosen colors.

- Choose the colors for the first few sessions, but invite the children's input in color choices, tools, and other options as the project progresses.

- Incorporate a variety of learning and working styles—gross-motor work or predicting outcomes of color mixing, for example—to attract as many members of the group and provide varied developmental value.

- Involve the children in simple research using books, the Internet, and visits to older children's classrooms or projects to enrich and extend the children's exploration.

The Canvas Project is flexible: it can be condensed, simplified, extended, or rearranged based on the group of children pursuing it. There are an infinite number of variations or adaptations you can add to the project. Below is one example of how the steps outlined above evolve in the typical life of the project.

Session 1: Large Rollers and Black Paint

Black paint makes a dramatic contrast to the white background of the gessoed canvas for the introductory session. The paint can be mixed with water, especially after one layer of black has gone on, to vary the tone and texture. The large rollers appeal to toddlers' interest in gross-motor work such as lifting, pushing, and crashing. They also allow very small children to reach across the entire space and contact each other.

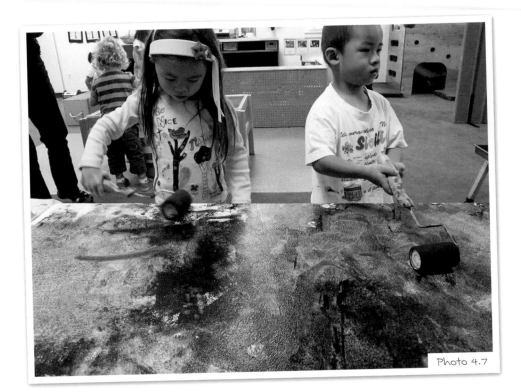

Photo 4.7

Begin with the canvas lying horizontally on the art table. (This project typically features a wide variety of orientations for the canvas, which I will detail later.) You may need to model the activity for the first child or two, but the children will soon discover how to manipulate the rollers to lay wide, fading black tracks on the canvas. As they experiment with the heavy tools, some will etch lines in the black with the side of the handle. Chopsticks, craft sticks, or similar tools can lead children to experiment with texture and negative space. Many children will discover the edges of the canvas and turn their rollers sideways to cover it.

Children will be inspired to cover the entire white canvas with black paint. The novelty of the project, combined with the stimulation of pushing and crashing the rollers, tends to create quite a charge! Besides offering sharp contrast, the black

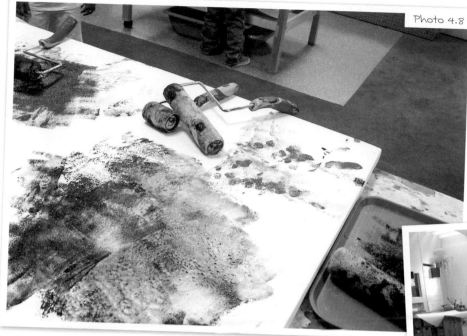

Photo 4.8

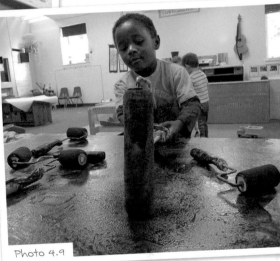

Photo 4.9

and the other muted tones, combined with the large tools, will create a background over which more controlled and representational work, involving bright and mixed colors, can be created later.

Session 2: Small Rollers with White Paint

Although it may not make much sense intuitively, returning to white produces excitement and reflection in the second session. Again, lay the canvas on the table. The smaller rollers make the job of covering the entire surface more challenging and tend to create a frame, with the center retaining more of the previous color than the edges. This is part of a dual effect that teachers can use to subtly guide the balance of the painting. The children's work gathers around the edges of the canvas when it is placed horizontally and moves toward the middle when it is arranged vertically.

In the first session we allow children to pile on as much paint as they desire. In subsequent sessions, we limit the amount of paint used and how it is applied. We usually don't dilute the paint. Dilution encourages a fading effect as the roller dries up and reaches the center of the canvas, causing a faded look. The children frequently will notice the patches of black poking through the thick white strokes, or the cloudy gray areas as the roller leaves a thin swatch of white.

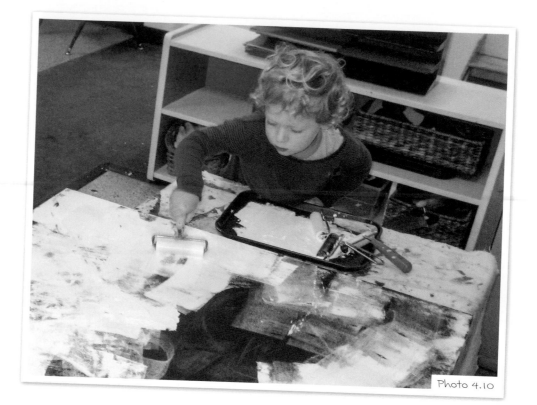

Photo 4.10

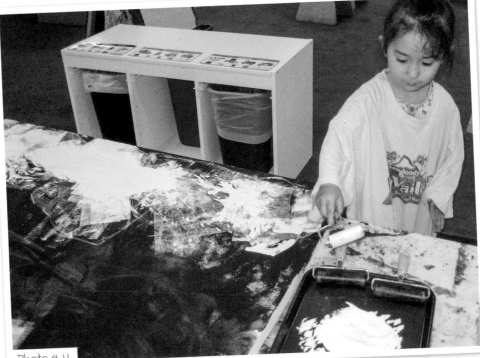

Photo 4.11

Session 3: Large Brushes

There is no rule for what color to do at this point. You could choose a shade of brown, which tends to inspire children's earthy, self-focused imaginations. You might opt for dark green or blue, either of which creates an evocative and vibrant effect. Or you could offer bright primary colors such as red or yellow. Children are always responsive to the effects of introducing browns and greens later, over the lighter colors.

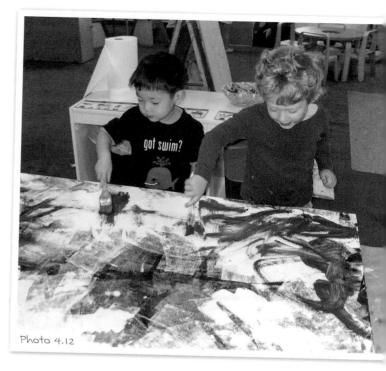

In this session, introduce large house-painting brushes or large squeegees. But keep in mind that large squeegees tend to pose gross-motor challenges, so that children often do not cover a great deal of the surface when using them. Squeegees can be used later in the process without covering too much of the previous work.

Photo 4.12

Brushes are a familiar tool that reminds children of their easel experiences and skills. Once the children find a recognizable art tool, they'll be on familiar ground and begin to think about their engagement in the context of past art explorations.

By this third session, you'll notice how the project supports and extends the children's emerging friendships. Pairs, trios, and small groups begin to appear over sessions at predictable times, engaging in the same ways. (Here is a good example of how documentation— especially photographs—can help you see how a specific group responds to a project and how to tailor your next steps.)

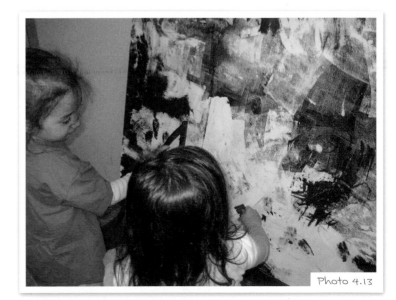

Photo 4.13

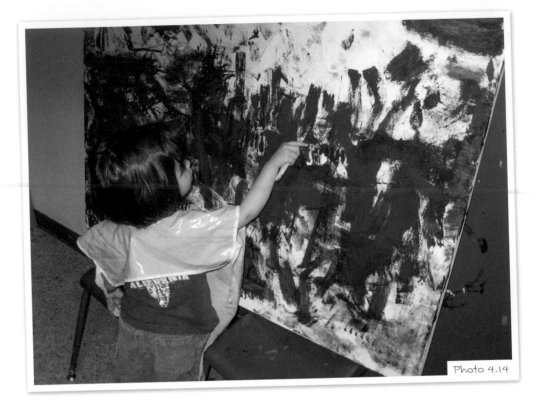

Photo 4.14

Another way that the project matches the developmental tasks of two- and three-year-olds is in the patterns left by the tools. Whereas the small rollers leave a pattern that becomes more transparent from edge to middle, the large brushes combined with a vertical canvas often create a contained, dense, rectangular pattern, like a large eyebrow or caterpillar, in the center of the canvas.

By the end of the third or fourth session, you may want to say, "Perfect! Stop right there." The canvas will have become a complicated but integrated picture.

From this general starting sequence, the project can progress in any number of different directions. With the canvas propped up next to you on the floor against the wall, ask children questions such as these:

- What color did we use first? Can you still see some of this color?
- How many colors have we used so far?
- What color do you like?
- Point to a place where you see your own painting. Tell us about it.
- Which tool did you most like? Why?
- What else do you see?
- What do you want to tell us?

Finally, ask children what colors they would like to add. Write down the children's responses with the name of each child next to his chosen color. Hang this list next to the canvas. Move on to primary colors for a few sessions, and then offer children smaller quantities of two (and later three) colors. This should coincide with the introduction of medium-sized tools like typical easel brushes or toothbrushes.

As always, engage the children in choices and preparation of the paints. You might wish to use large cafeteria trays for the early sessions. Later, when you are mixing small amounts of several colors, you can use palettes with several small wells. As always, be mindful of the possible effects of the color combinations you provide in each session. It's not a tragedy if the children cover a large portion of their past work with a drab greenish gray. Remember that the project tends to surprise in its ability to evolve. However, if each session can produce a subtle shift in color and pattern, so much the better for the children's and the adults' sustained interest.

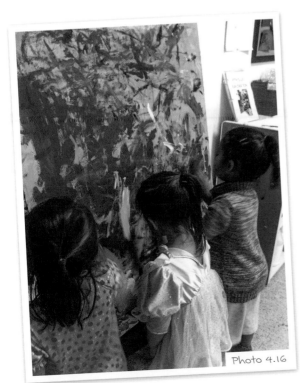

Photo 4.15

Consider using acrylic paint rather than tempera, which fades quickly. A canvas painted with tempera will eventually lose its rich hues, and each new layer will tend to pick up the layer underneath it and become brown.

Beware: acrylic is indelible. It won't come out of clothes. And children's skin should never receive prolonged exposure to it. It is not toxic, however, and comes off skin easily with soap and water. And it makes for much more exciting color and color separation. The challenges of acrylic can be worthwhile because of connections to adult art making and layers, two of the key themes of the project. You will need to decide what media are best for the children in your care.

Photo 4.16

Over the course of the Canvas Project, move from larger to smaller tools, and provide a variety of motor options. Starting the project with gross-motor challenges connects with the gross-to-fine nature of development, and it attracts many children, especially boys, who, even at this age, can be skeptical about art. But it also supports the generally abstract, sensory stance the art of younger toddlers tends to have.

Here are some of my favorite examples of sessions:

- Give the children large spongy balls to roll in paint and throw at the canvas.

- Hang the canvas up high, and offer children flyswatters or paintbrushes taped to long dowels to reach it. You can also help the children gently swing the canvas on its rope and paint it as it moves. (This is often children's favorite session!)

- Put toy cars in paint, and drive them onto a horizontal canvas.

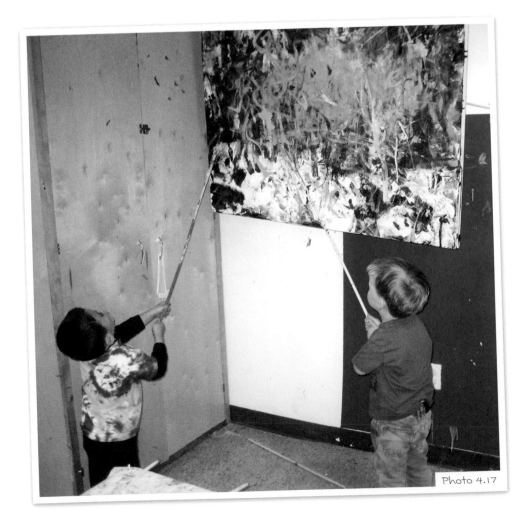

Photo 4.17

Each of these approaches tends to leave large swaths of paint, which supports the visual plan of background to detail. As the tools become smaller over the course of the year, children's fine-motor skills will sharpen. Children will begin to move in closer to the canvas and challenge themselves to produce shapes and glyphs in small corners.

As you fine-tune the materials to support growing representation and control, you can try:

sponges	spoons	flowers or twigs
feathers	marbles	Ping-Pong balls
cotton swabs	cotton balls	eyedroppers
toothpicks	pipe cleaners	

Interest in reproducing letters or images emerges at this point as well. You'll see circles with facial features, letters, whole names, or other images floating over the large fields created in the early sessions. The children will often remark about the effect of seeing detailed, representational images tied together by the foundation they laid earlier in the year.

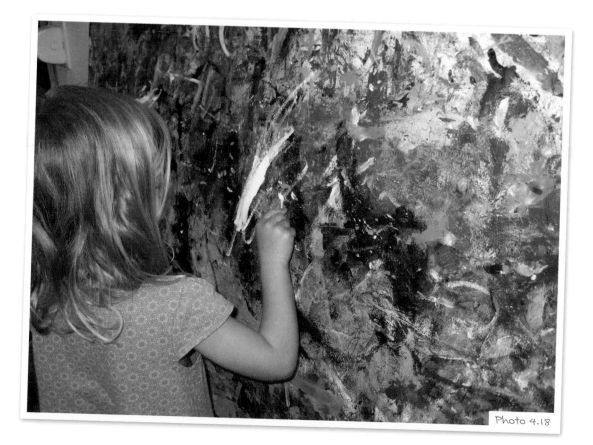

Photo 4.18

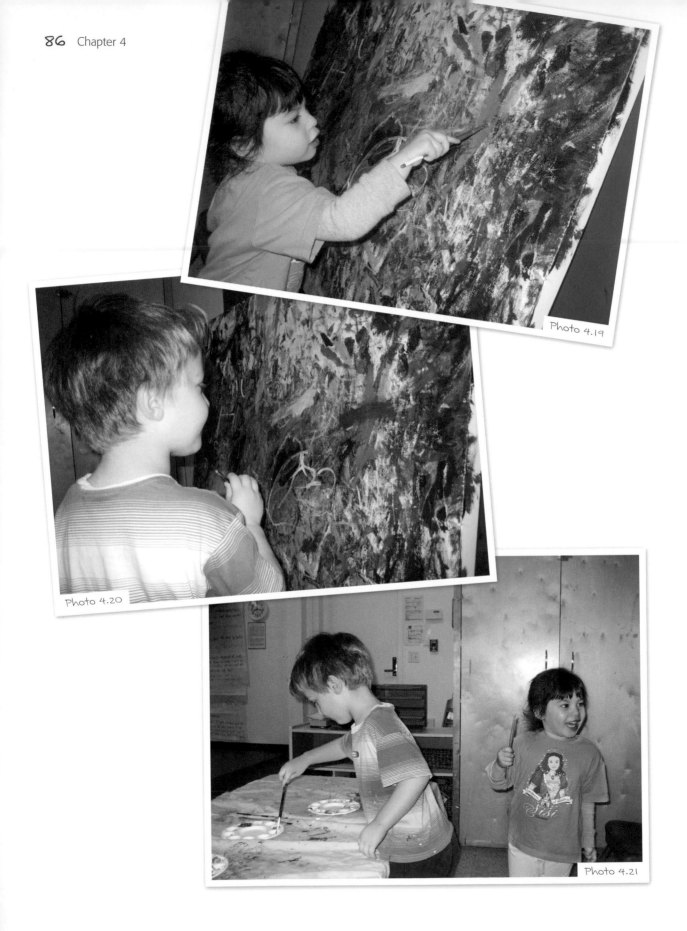

Photo 4.19

Photo 4.20

Photo 4.21

Study Other Artists

Keep a small library of books featuring art reproductions. Have small groups of children look at the pictures in the books midway through the project. This will inspire discussion and planning among the children, who will see how their process of creating and displaying art is connected to the adult world. Consider going online and showing video of artists such as Picasso or Jackson Pollock at work. (At The Little School, one three-year-old asked, "Is that our canvas?" as we watched Pollock throw paint at the ground.)

Revisit Past Sessions

Children often voice new ideas, connections, and enthusiasm when they look at pictures or video clips of recent Canvas Project sessions. You can show photos or video once or twice during the course of a project to help children visit previous work or to inspire new ideas. Similarly, you can involve children and families in the documentation process as they arrive each morning. You might recruit a regular canvas partner who expresses interest in arriving early, helping set up materials, or taking pictures.

Toward the end of the project, you can hold a meeting with the children in which everyone sits very close to the canvas and, using pictures of past sessions, tries to find each color applied to the canvas so far. You can have children look at photographs of sections of the canvas up close or with flashlights or a large window frame cut out of poster board.

Creating Studies

School-age children are expected to be able to write or sketch out a basic idea and then flesh out the details. Whether organizing an essay, a science project, a dance piece, or a graphic design, older learners need to know how to balance brainstorming with organizing and refining. These same skills can begin to be developed in younger children.

The idea of drafts in writing is crucial to transforming a bare idea into an effective argument. Sketches or *studies* move drawing or painting projects along. In every realm, we can use the idea of drafts, sketches, and studies to encourage children to represent ideas as they are forming, with no concern about immediate outcome. Especially since young children tend to work in short bursts, promoting studies helps them understand how to use little steps to make something big, which can encourage young children to dedicate themselves to a long-term process.

Extending the Project

Offer some related or parallel projects to expand the children's thinking and exploring. As the children become experienced and enthusiastic about working together on art projects, similar materials or experiences in other areas can extend their emerging interest.

Painting something three-dimensional—often a discarded object of interesting shape—can give children the experience of three-dimensional spatial reasoning and maneuvering a brush or roller over a multidimensional surface. (See chapter 5 for more ideas about three-dimensional art.)

One extension involves giving each child a small, two-inch square canvas that they paint for about six sessions. Children will need to use tiny tools like toothpicks to paint on the canvas. A piece of wood or even cardboard can provide the surface for quick studies that can be done outside with natural materials such as ground chalks.

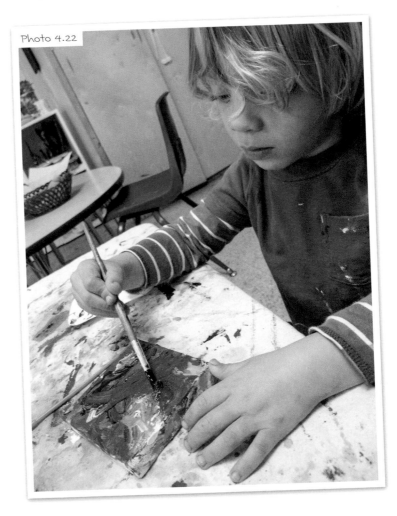

Photo 4.22

Once at The Little School, in the midst of a canvas project, a student brought in a black-and-white poster of birds and clouds and announced his intention that the class paint over it. The results of this one-day mixed media project moved one and all.

The Culminating Event

The project approach, with its emphasis on fostering skills of inquiry, stresses the value of a culminating event. Here the children can organize, document, present, and explain their work to others as a means of integrating and maximizing their learning. This can be done on a smaller scale with the Canvas Project. If you have slide shows, videos, panel displays, or other projects like the small canvases, you have a natural selection of items for an art show.

Invite families for an afternoon or evening event and serve special snacks. As with visiting the art store, the culminating event gives teachers a chance to explore art's place in the classroom and curriculum. Teachers can visit websites of gallery openings and museum shows for ideas on how to set up the event.

Teachers and families can collaborate on a Canvas Project book as a culminating event. Several web-based services and software applications are available that make book design and production simple and adaptable to your needs. In creating the documentation for the Canvas Project, choose carefully the wording to accompany your effective and organized photographs. Keep the aims of documentation in mind: explain the goals and benefits of the project, and describe the experience to children and families alike. A book like this will enjoy a high status in your classroom; you may find that children request and read it often. It may also serve as the script at the start of a new project by showing children the steps of the process.

A NOTE ON SMALL-GROUP WORK

The idea of teachers working with small groups of children is integral to project-based curriculum. The benefits of project work—collaboration, negotiation, sustained engagement—are optimized in concentrated settings.

Most programs find it challenging to dedicate one teacher to just three or four children, but doing so is worthwhile and rewarding. Family members or other staff can be enlisted to pitch in for short stints to allow a teacher to gather materials or work with a small separate group even in the same room. Such staffing and

grouping puzzles often inspire creative thinking that strengthens collaboration among adults and improves the program.

Many of the project elements described above—the small canvases, the meetings and discussions, revisiting the project through documentation, researching art books and videos—work particularly well with just a few children. The environment is quieter; the level of arousal is lower; the opportunities for each child to work with a teacher or contribute her voice are more abundant.

Even when staffing or space does not allow small groups to work together, dividing a group in half—into small groups of eight or ten—can offer similar benefits. In my classroom of two teachers, we separate our older group at snacktime. At the start of the year, when they are between two and a half and three, we focus on having snack together. Soon, we read a book or draw on the chalkboard after snack. As the Canvas Project begins to gain momentum in January, we do some simple, related projects such as the extensions described above.

Separating children for different activities can help strengthen relationships between children who like similar activities; have similar (or complementary) exploration, thinking, or learning styles; have an important emerging friendship; do not yet know each other; or perhaps could use a break from one another.

CHAPTER SUMMARY

In this chapter, I have distilled the basic ideas and strategies for scaffolding project work into one important project. In the final set of projects in chapter 5, I include the one piece that is missing from a traditional painting: depth, dimension, and shape. These projects help children round out their thinking and motor skills as they leave toddlerhood behind and engage with the kind of learning that awaits them in school.

New Dimensions in Thinking and Constructing

As I wrote in chapter 2, some of the latest ideas about children's cognitive development focus on how their thinking gains depth and dimension as they mature—as opposed to just moving from one level to another. This can be seen very clearly in the evolution of children's drawing skills (Case 1985). They begin by depicting a flat face—a circle and a few dots—hovering without any setting or background. Just two or so years later, they are drawing bodies with limbs, hair, and clothing and having figures interact with others

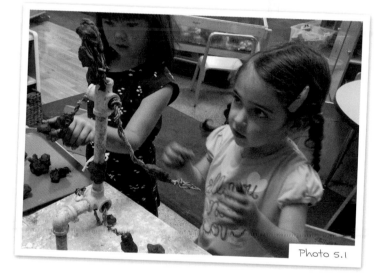

Photo 5.1

on a background that stretches off in the distance behind the subjects. They have developed a rich representational scheme to depict a deeper and broader view of themselves and the world.

Physical dimensions are just one plane along which children begin to think and act in more complex ways. Their social relationships, their knowledge of culture, their understanding and use of language, and their motor skills all enhance in breadth and depth as they take great leaps forward.

In particular, they begin to work from an idea or question—a hypothesis—and organize their actions around concepts rather than the other way around. They continue to use thinking to make sense out of sensory experience, but increasingly

it is their ideas about experience that drive their actions. And they seek out more challenging and detailed processes to make sense of.

Creativity becomes more about planning, technique, tools, negotiation, and challenge. As these dimensions come into play, you can turn to projects that offer greater depth and detail. This might be the symbolic dimension, such as a story or performance, or a method of dividing up labor. But you can also use three-dimensional objects in art to meet children's more dimensional thinking.

There is another reason to offer three-dimensional projects. In the past, American children encountered 3-D spatial reasoning and problem-solving challenges everywhere: fixing a wagon wheel, milking a cow, building a fort, baking a molded cake. Concerns have been raised over the disappearance of spatial reasoning in childhood (not to mention adulthood), just as learning from nature and physical labor have become rarer. Visual-spatial reasoning promotes thinking along multiple abstract dimensions—as in sorting things by both color and size.

The projects in this chapter extend the gentle and flexible approach to steps and methods into the years when work becomes the main purpose of school. Like some of the earlier projects, they incorporate other areas of learning: emotional mastery, cultural literacy, narrative understanding, and sequencing. But where earlier projects merely suggested ways for children to organize their ideas and work together, these three-dimensional projects focus on negotiated and planned group experiences and embed more preacademic skills such as math and literacy.

PROJECT The Lion Head Project: Transformations and Mastery of Fears

There is a narrow rectangular window that looks out from our toddler classroom to the communal entryway at the school. Almost every year around January, Lunar New Year decorations, including an elaborate lion-dancing mask, appear in this area, right across from the window.

Javier, a verbal and sensitive two-year-old, noticed the lion head right away and seemed unable to think of anything else. He had just begun to settle into the program after a teary first few months, and suddenly the lion mask outside the window, right where he liked to wave to his mother, started adding to his already-fragile transition into the school day.

But this was about more than longing for mom and being in a new place with new adults. Like many two-year-olds, Javier could read the symbolic meaning

of the mask: it was meant to be a fierce creature. He couldn't contain his feelings; he couldn't comfort himself through knowing it wasn't real or alive and couldn't hurt him. His emerging ability to imagine loomed uncontrollably large.

Part of what helps older children and adults distinguish between a real lion and a mask is their understanding of what the mask really is and how it got that way. We know that someone took paper and wheat paste and made a frame, and then they adorned it with feathers, paint, and so on to make it look like a lion.

That tells us that this kind of mask—even if we have never seen one—is part of positive ritual in our culture. It represents the thinking and actions of others over time. This "theory of mind" (Meltzoff 2003; Bruner 1981), the understanding that other people think and feel independently of you and affect your experience, develops gradually over the early years—often stimulated by experiences like Javier's.

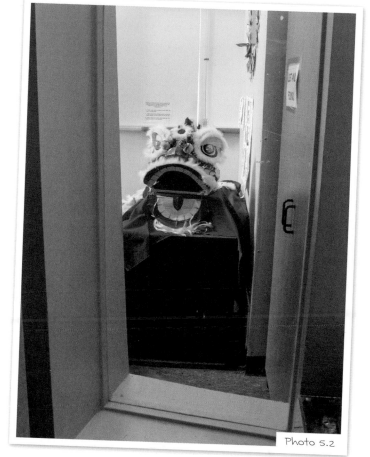

Photo 5.2

The Lion Head Project is designed to make the transformation of raw materials into a symbolic prop as a script for mastering fears and imaginings. By turning everyday materials into an evocative costume, you can pair the focus on exploring sequences with an exploration of the qualities of pretending, fear, power, and control that older toddlers seek out. This is reinforced by using a costume in movement and playacting. Like the other projects in this chapter, the Lion Head Project extends beyond expanding art to three-dimensional costumes to add music, dance, imagination, social interaction, and cultural inquiry.

WHAT YOU WILL NEED

- a sturdy cardboard box, such as a fruit delivery box
- yellow, red, and gold tempera
- glue

- collage materials—such as *lei see* envelopes, Lunar New Year banners, crepe paper, or fabric strips

- a long piece of fabric to make a tail for the lion (this can even be a blanket or tablecloth that you staple on and then return when the project ends)

- white poster board

- construction paper

- a sequence of painting tools (see the Canvas Project in chapter 4 for suggestions)

- scissors

- stapler

HOW IT WORKS

Start the Lion Head Project with cultural exploration or "research." If you hold Lunar New Year celebrations, you may already have some lion head masks available, so children's engagement with them will happen as a result of their social life in your program.

A good book to introduce children to lion dancing is *Lion Dancer: Ernie Wan's First Chinese New Year* (Waters and Slovenz-Low 1990). It depicts a young boy practicing and performing a lion dance while celebrating Lunar New Year with his family. You can find recordings and videos of lion dancing, lion dance drumming, and other Lunar New Year celebrations in music stores and online.

The concept of research is important in this project for several reasons. First, it extends the sequence of thinking about projects that begins with the sensory-based explorations in chapter 4. Piaget stressed *metacognition*: thinking about thinking, especially one's own thinking. This project fosters thinking about thinking about an art project. But it also fosters thinking about thinking of yourself, your fears, and the expectations of others. You can think of this project as a model for a child to conceive of his own maturation and reflect on where he wants to take his explorations next.

Second, using not just imagination but also art to support children's mastery of emotional challenges gives you a chance to present emotional development as a research project. Controlling fantasy and fear is defined as a safe, intriguing, natural project, just like the cognitive challenges that Piaget saw as driving development. When a group of peers and adults researches fears with a celebratory project, it takes the focus off of the individual and her sense that she alone considers something risky, and it identifies fear as something manageable that everyone experiences.

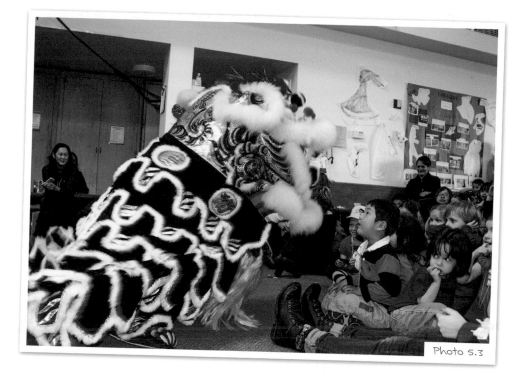

Photo 5.3

In addition, this project focuses on multimodal learning. It incorporates many different themes in its explorations, including dance, music, culture, community, symbolism, time, seasons and calendars, and families. And these themes naturally occur in the places and times when exploration usually happens: in the dramatic play area or at group time. The project is designed to welcome children into it in the places, ways, and times that speak to them. Children not only find satisfaction in being part of a group but also buy into the idea of participating in groups without losing a personal sense of self.

Here is another point to consider: many children who love storybooks, dramatic play, or gross-motor exploration conceive of themselves as "not liking art" even by age three. On the other hand, as I described with the easel in chapter 3, many children will establish the art area as a home base early on. There they can not only exercise strengths and preferences but also observe from a safe distance the emerging social scene and its often wild physical and emotional nature. These children, not coincidentally, are often (but not always) fearful of things like lion masks.

This is a natural and healthy stage of development. The basic ideas of inclusion described in *Including One, Including All* revolve around helping children find both a clear definition and an accepting, informed sense of self, especially their strengths and preferences (Roffman and Wanerman 2011). To help children

expand and extend each other's learning (and their conception of themselves and their social groupings), you can bring children's different learning and social styles together through scaffolded curriculum and structures.

The Lion Head Project, for example, evolved in response to Javier and a few other children many years ago. But it has proved to be a template that responds to at least a handful of children each year. We organize, negotiate, and develop the project differently with each group in order to respond to the individual and collective learning and social styles of each child and group.

The Lion Head Project brings the artists, the wrestlers, the block builders, and all the other overlapping styles and groups together. The cerebral or sensitive children get under the lion mask and growl at their loudest, most extroverted peers. The children who can jump into pillows or line up animals all day find their way to the art table. Teachers find countless ways to prompt children to share their expertise and passion with each other when someone is trying something new.

The sequence of the art project is simple and flexible. The potential of the overall project relies on how you incorporate these other elements into your project and frame the making of the lion head.

Start with a bare cardboard box. The project thus begins with a harmless, everyday object. Sometimes, if one or more children have been very talkative about their fears of masks or costumes, you can set up the emotional theme of the project at the start. "We're going to make our own mask," you might say, "and we won't be scared of that." The nature and process of the project communicate the same message: demystifying a pretend object whose real nature and origin seem mysterious.

The first step—painting the box red, gold, or a combination of both—often inspires sustained work over several sessions. You can begin with the same small rollers that you used for session 2 of the Canvas Project, but medium to large brushes will work well. As in other projects, moving in from large to small, basics to detail, underscores the habits of sequential inquiry you want to inspire. In this case, children move from ordinary and inert to fanciful and animated.

Ordinary tempera paint will hold many materials on its own as you move into the next step: adding a collage element. You can also use glue to signal a new part of the project. For this step, use scraps or snips of colored paper, banners and calendars from past years, or perhaps a newspaper with a story about Lunar New Year. Red and gold are usually associated with the Lunar New Year and frequently appear in children's books on the subject, and they provide an inspiring spectrum for color-mixing experiments. As with the Lei See Project (see chapter 3), you can put out scissors, banners, and envelopes, as well as other Lunar New Year ornaments for children to add (or remove) as they work on the box over a few sessions.

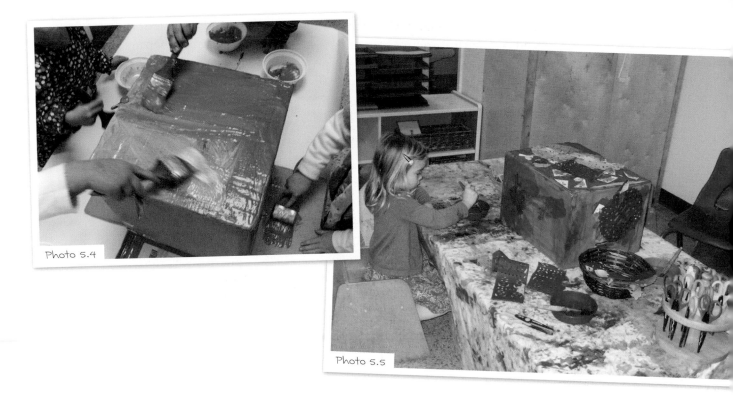

Photo 5.4

Photo 5.5

At group time or in special class meetings, review and discuss the plans for the project. Share depictions of lion-dancing masks from books, and write down the children's comments or ideas on a dry erase board or a piece of easel paper. As you compile project documentation, you might share some photos with the children when you review your progress.

As the children add collage to the painted box, they might notice the puffy pom-pom adornments on lion masks. Simple pom-poms and feathers from discount catalogs can finish the fur of the lion effectively and often provide a transition to the children's next objective: the lion's face.

Pom-poms often function as a nose and even a simple mouth. At this point, you may want to provide some adult scaffolding to explore shapes and parts of the lion's face. Children love to discover that the teeth are triangles and the eyes two sets of circles or ovals (with, if you feel ambitious, a thin triangle cut out of each black inner oval for contrast).

Share the title page of *Lion Dancer* with the children. It depicts Ernie Wan peering out from the open mouth of the lion mask. Children may then be motivated to make a working mouth. Here you'll do research to determine how to cut out a rainbow shape from the base of the box and use brads to hinge it to the box as a lower jaw. Then glue the teeth to the bottom jaw, which can also be painted, collaged, or outfitted with any number of tongues!

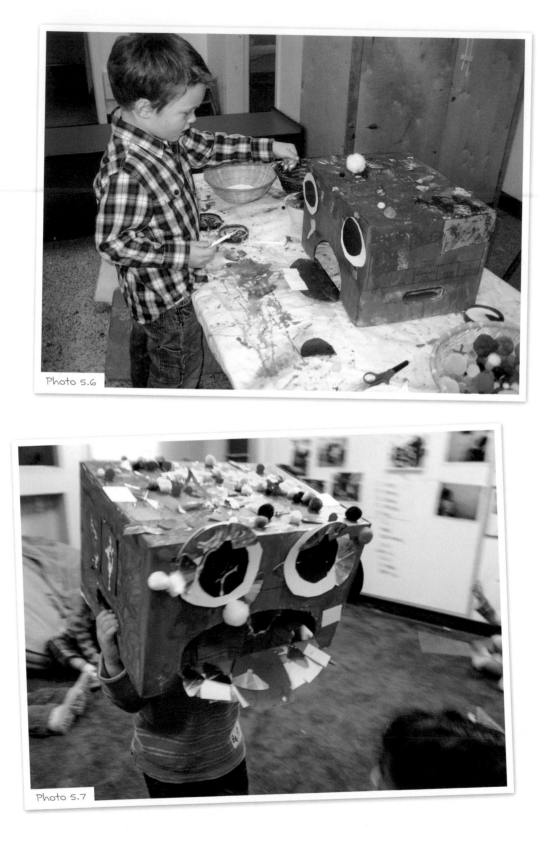

Photo 5.6

Photo 5.7

The lion dance is performed by two persons, one moving the head and the other providing the back half, including the long streaming tail, which may catch children's attention. To make a tail you might simply staple a red or animal-print blanket to the back of the box temporarily, allowing several children to participate at once during the lion dancing. But if children show interest in making tails themselves, invite them to adorn scrap fabric with crepe paper or other fabric strips to make a more elaborate lion tail.

Photo 5.8

Photo 5.9

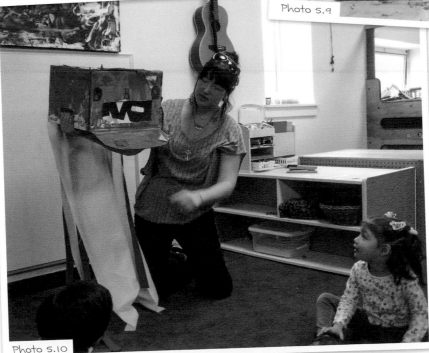

Photo 5.10

This version of the lion is somewhat preprogrammed by adults. Keep in mind that a well-organized transformation of an ordinary box into a believable object—the art project as emotional mastery—is the focus, so a bit of teacher guidance toward outcomes makes sense for this project. Regardless of how much the finished lion mask resembles the adult preconceptions, always engage the children in each part of the process, and explore each choice with open-ended questions.

Toddlers and young children are naturally inclined to figure out how to break down an image or idea—say an animal face—into achievable basic shapes and motor challenges, so this project is based on that process. At the other end of the spectrum, children may come at the idea from another angle. At The Little School, we have at times come to the art table to discover a lion face fabricated from pom-poms, packing peanuts, and feathers. Often the group will agree that this is the finished face. So while there are reasons for this project to reach a certain representational outcome, there are infinite ways to partner with the children to tailor the process to each group.

As you discuss projects with two- and three-year-olds, remember to use simple documentation practices to review, extend, and share your learning process with the children, other teachers, and families. Taking pictures of discussions and written records is a quick and easy way to preserve lists and plans. It also helps children revisit not just their words but also the context and feelings from which they came. This documentation-on-documentation approach acts as a model for sequential observing, discussing, thinking, planning, and implementing projects in a fluid, evolving way.

When children see lion dancing with drumming, they can't help but notice how the drummers pound out some beats on the skins of their large drums but also accent those powerful deep tones by tapping out some beats on the wooden sides of the drums and bringing their sticks or cymbals together over their heads.

To extend children's interest, you can offer the children simple motor challenges like pounding out some beats on the rug and showing them how to bring rhythm sticks together over their heads. Some children, especially those who have found lion dancing intimidating, may at first be anxious or hesitant. Allow these children to keep their distance from the dancing or put on "magic ears" (sound-muffling headphones).

To help more anxious children, you can introduce the idea that the drumming can make the lion back off. This is a slight twist on the actual belief that the lion and the drums ward off bad luck, but one that helps more sensitive or anxious children prepare for the upcoming lion dancing.

This all segues into the culminating event of the project: lion dancing with the finished mask. Be sure to discuss this goal with the children throughout the mask-making process and during meetings and music and dance exploration.

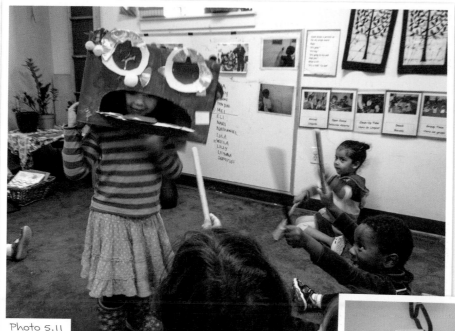

Photo 5.11

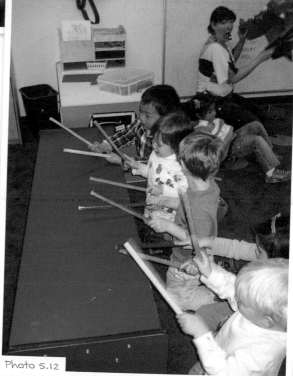

Photo 5.12

When you are ready to introduce dancing, use the opportunity to explore the links among symbolic rituals, turn taking, and literacy.

You'll need to explain how the lion mask can only accommodate three or four children at a time: one in the head and two or three in the tail. One child starts inside the head, holding the sides of the box with her hands and looking out the mouth. Remind the dancer in the lion head how lion dancers lift the mask up and down and rock it from side to side to make it look alive.

Put on the lion-dancing music, and use rhythm sticks to play along, calling out, "Back off, lion!" when it comes close. After about forty-five seconds, turn the music off, and help the dancer in the lion head move to the back of the tail, while allowing the other dancers to move up. After about four minutes, the first group of dancers will have all had a chance to operate the mask, and another group of three can take over. This way, after three or four days, everyone will have had lots of chances. (You can increase the literacy learning by making a sign-up sheet on easel paper or a chalkboard.)

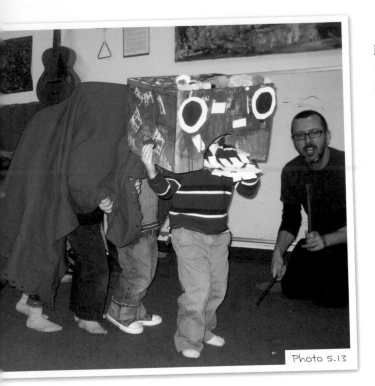

Photo 5.13

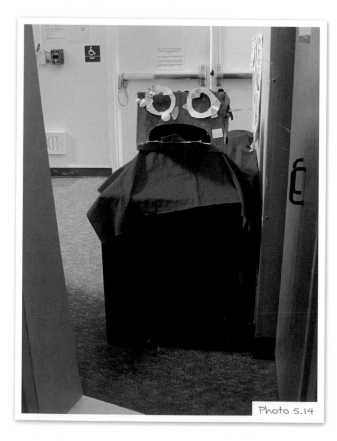

Photo 5.14

Here, knowledge of individual children and planning can play key support roles. With a little encouragement, some of the children who are fearful of the lion dancing can take early turns in the head of the lion. Often, being inside the scary persona is much more comfortable than having it come at you. Role reversal as a cognitive, linguistic, and emotional tool is particularly important at this age.

A few children may not feel ready to get inside the lion head or tail. Teachers can remind and model for children how they can bang their rhythm sticks together if the lion comes close.

At The Little School we almost always find that two-thirds or more of the class clamors to be inside the lion costume on the first day, while about a third show reticence or anxiety. As we go through our turn-taking process over three or four sessions, however, things begin to balance out. Those who were eager to take on the powerful, frightening persona find an interest in watching the lion come close and making a commotion to ward it off, while those who initially trembled in a teacher's lap often bear down fiercely on their peers from inside the lion head.

Be sure to take lots of pictures and video of the dancing part of the project. You can share this documentation through a blog or as a slide show. If you have the opportunity, you might offer to lend the mask to a local Lunar New Year celebration.

At The Little School, after we had gone through an early version of this process, Javier, a veteran of both the fabrication and the lion-dancing stages of the project, still often commented on the lion mask just outside the window. "That's just a pretend mask," he would say. "It's scarier than ours, but it's just a mask."

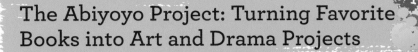

The Abiyoyo Project: Turning Favorite Books into Art and Drama Projects

As children mature through toddlerhood, they begin to take charge of their own learning—through play and through exploring materials. As demonstrated in the Lion Head Project, imagination and representation are natural initiatives at this stage.

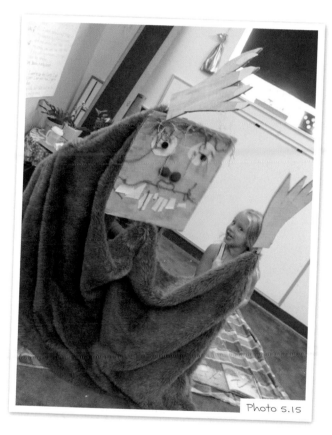

Photo 5.15

At the same time, children begin to express a strong desire to play together, often around pretend elements. Imaginative play is an art in itself, and it connects to creative pursuits: dance, theater, design, scenery, and, central to this project, story.

Children in the early stages of imaginative play rely heavily on support. They base their fantasies on real life, and they are drawn to detailed, lifelike props and costumes. They also use favorite stories, songs, fingerplays, and chants as the source for symbolic play. As they mature, their fantasy becomes less tied to real experience. Basic objects, like a block, can become fanciful tools, while princesses, fairies, superheroes, and especially monsters begin to appear in their play.

Children ages two to three in particular have a passion for reading and rereading storybooks, coinciding with their early forays into independent, interactive pretend play. In the book corner, the teacher with the familiar voice and cadence, and sometimes also the lap, becomes a storytelling version of the "secure base" described in attachment theory—the safe home from which to explore independently (Bowlby [1969] 1982; Lieberman 1993). This home base offers not just a trusted adult but also favorite "scripts" to return to, such as those that describe the attachment dance of going off into the unknown and then returning to home and family.

The Lion Head Project demonstrates how art can help children further their emotional processing and regulation of fantasy. This next project adds the elements of collaboration around a script. The mastery of fearful fantasy figures reappears, as it does so often in children's literature. So does a musical element.

But this time, the children work together to animate and then subdue a beast, telling a story (based on a flexible adaptation of a well-read "script"). The repetitive enacting of the story helps an older toddler group stage their transition to full-fledged collaborative project work, with examinations of character, design, music, narrative, literacy, math, and physical science.

The first step in the project is to read and reread *Abiyoyo* (Seeger 1986). (This book has been a favorite with our two- and three-year-old groups year in and year out.) The story of a monster that menaces a whole community, outsiders redeeming themselves, and fears conquered through dance and music typically appeals to many children. And of course, Seeger's masterful, engaging voice and the combination of image, word, and song make the story particularly powerful.

As with other seminal fantasy monsters—like the troll in "The Three Billy Goats Gruff," the witch in "Snow White," or even Ed Emberley's *Go Away, Big Green Monster!* (1992)—some children revel in their ability to take it in calmly, others are frightened but not overwhelmed, and others are quite scared at first. Many a parent has reported to me how *Abiyoyo* has dominated their family life (and sometimes their sleep schedule!) for a week or so. But all remain fascinated and demand to read it again and again.

You might want to vary your exploration of the book with music. You might read the story with a guitar nearby and pick it up when the boy in the story begins to play. (Of course if you don't play an instrument, the next step could be to use the story CD by Pete Seeger. Video excerpts of Seeger performing "Abiyoyo" can be found online.)

The flow of the book naturally regulates the children's energy. First they are light-hearted, as the father plays tricks on his neighbors. Then they are crestfallen, as the boy and his father are ostracized. Next, they are enthralled and fearful as Abiyoyo appears and terrorizes the town. Then they are earnest and yearning as the boy hatches his plan.

When the boy's song comes into the story, the suspense has been building for quite a while. The children, like the characters in the book, may use dance to purge the tension and fear of the preceding pages. They might imitate the ecstatic giant, jumping up and down and stomping loud enough to shake the floor. When the energy reaches its peak, the story calls for the giant to fall down, exhausted, and the father makes him disappear. The song is then reprised as a celebration and finally, taking a cue from Seeger's performance, as a calming lullaby.

The music gives you a second script for acting out the story, one that not only guides the children's energy but also organizes and supports their interest. From this point, you can suggest all sorts of creative projects to continue your engagement with the story.

WHAT YOU WILL NEED

- cardboard
- tempera paints
- textured materials like yarn or twine
- thick wooden dowels or PVC pipe
- a large piece of fabric
- duct tape
- twigs or other sources for "magic wands"

There are any number of ways to make large puppets. You could use papier-mâché, boxes, tubing, ducts from the hardware store, or even a wheeled office chair as a base for an easy-to-move mixed media figure.

HOW IT WORKS

The core of the project is to create a giant Abiyoyo puppet that the children will operate together. The book *Abiyoyo* may inspire a lot of questions about design and representation. The giant, depicted in oil-on-canvas paintings by artist Michael Hays in the book, first appears as a silhouette, then as a shaded outline. When the boy and his father first encounter the giant, and the reader first sees his face, the text reads (Seeger 1986, 24):

> There was Abiyoyo! He had long fingernails 'cause he never cut 'em. He had slobbery teeth 'cause he didn't brush 'em, stinking feet 'cause he didn't wash 'em, matted hair 'cause he didn't comb it.

A few pages later, when the boy lures Abiyoyo into dancing frantically, three separate images of the giant show him moving across the page. Children may ask, "Why are there three Abiyoyos?" All of these clever effects engage children's deep interest in studying Abiyoyo's face and figure.

When you begin construction of the puppet, bring out a bare, large piece of cardboard and a copy of the book. Explain that the group will make a giant Abiyoyo puppet, beginning with the face. From here, begin your research around basic shapes: Abiyoyo's head, nose, eyes, teeth, even his hair. Then go on to talk about hands and fingernails. Sometimes children may also want to make his feet, following the details in the story.

For the first day or two, use markers, crayons, or pencils—fine-motor tools—to sketch the various shapes in Abiyoyo's face. Some children may occupy themselves with his eyes, others with his mouth and teeth. Some might draw a study of his whole face before working on pieces. With questions and guidance from teachers,

children can sketch in their designs: a head, hands, fingernails, and teeth.

The process of drawing sketches and drawing over them to come up with a refined pattern offers children of this age a model for working quickly at each stage while still methodically pursuing projects over time—the notion of "drafts" or "studies" discussed earlier.

The children can move right into cutting and gluing shapes onto their sketch. Eyes or teeth are often their first area of focus. Glue sticks can allow children to work quickly and downplay the sensory exploration element.

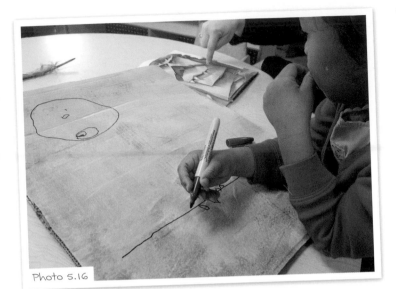

Photo 5.16

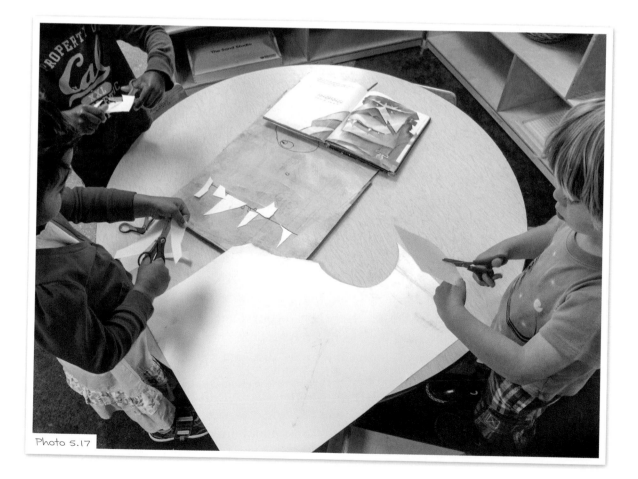

Photo 5.17

For the next few sessions, the work will center on the details of the face and hands. The question of how to make the hair might bring in media such as yarn. Discussing well-defined options, such as the size and number of pom-poms to use for the eyes or nose, can bring in negotiation and concrete academic challenges.

Children may tend to model their Abiyoyo closely on the images in the book, but they also may introduce their own ideas, such as a mustache or beard. Even when they try to reproduce what they see, they will discover original effects. "He needs hair in his eyes," a child decides, and adds an all-important finishing touch.

But even allowing for children's input, the art element here is streamlined and somewhat programmed by teachers. This keeps the focus on combining media and expression; the goal is to move the storytelling and acting along.

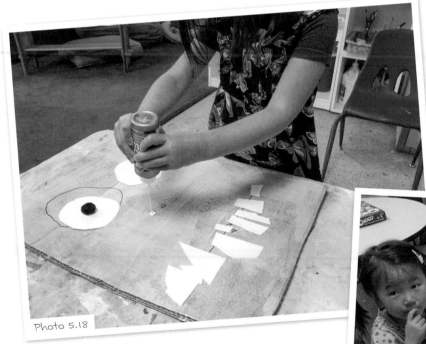

Photo 5.18

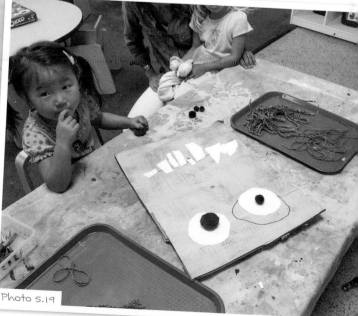

Photo 5.19

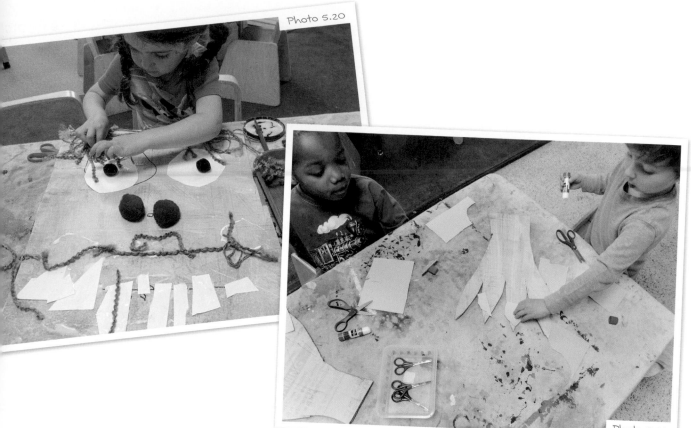

Photo 5.20

Photo 5.21

The Abiyoyo puppet, costumes, and props are pieces in a process of collaboration that moves toward a culminating event. However, depending on the age and interest of your group, you can negotiate, vary, or improvise any of the steps to increase the children's engagement with the puppet itself.

When work on the hands and face winds down, you'll want to wrap up this stage of the project by stapling or taping the hands and head to the top of the dowels. Then connect them with fake fur or some other fabric. You can involve the children in this part, which offers exploration of physics and spatial problem solving.

Children naturally like to keep reading the story and listening to the CD as they create the puppet. This is a perfect time to explore acting out the story and song. With toddlers, you can organize story drama very flexibly and simply. Read the book as you act out the story. Let everyone play whatever part they want, even if you have ten fathers and six boys. You might experiment with changes in language or plot. Use defined areas in the room or furniture as simple landmarks for directing the children's physical interaction with each other (what is called *blocking* in theater).

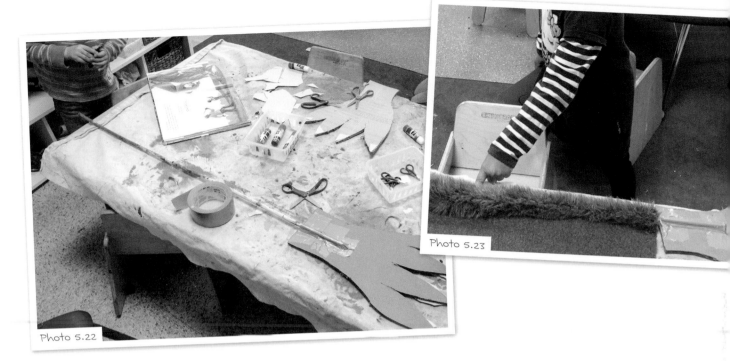

Photo 5.22

Photo 5.23

As children act the story out, think about props or costumes you might want to make to go with the puppet. You might use sticks and beads to make magic wands, spare cardboard and yarn or rubber bands to make ukuleles, and newspaper and tape to make hats like the father's. Each of these projects offers chances to explore shapes, quantities, measurements, relative size, and scale.

Enacting a storybook offers many benefits to children at the beginning of group imaginative play (Wanerman 2009). The storybook script helps children come together and organize character and story in a way that is typically beyond a toddler's skills. It also provides a sequence for the emotional resolution that is so key to children's interest in adventure stories. Children are drawn to books like *Abiyoyo* because they take them to the edge of their ability to address fear with cognition. The feelings are almost overwhelming, but not quite (or perhaps more accurately with toddlers, they can be overwhelming at first but not forever).

When children try to independently adapt these themes into improvised play, they typically get stuck at the point of danger or conflict—someone in distress or a never-ending swordfight. You can trust children to learn from exploring these moments over and over again. But using story to get through a narrative sequence to the point where fear and conflict are resolved can inspire and inform them as well.

The climactic moment in *Abiyoyo* is especially effective for children because it focuses on music's cathartic effect as well as its soothing, regulating effect. It is marked by the introduction and evolution of a song.

Another benefit of story is its multiple roles and jobs. Some children are inevitably drawn toward being figures of menace and power—others toward heroism or protection. Others may need to get involved more tentatively. You might ask these children to take on the role of page turner. This puts them in charge of research and literacy learning but also gives them the director role while still allowing them to occupy the sidelines.

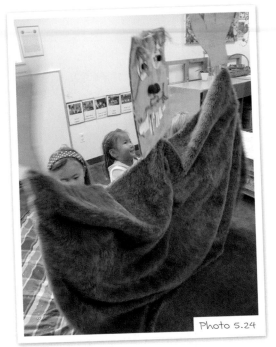

Photo 5.24

Remember, also, that the project can spread throughout the room and inspire other kinds of work: children can work on sequencing the different parts of the story or making their own Abiyoyo sketches and books at the writing table. You might offer figurines to explore *little*, *big*, and *giant*, and invite the children to build the story in a fine-motor realm.

The finished Abiyoyo puppet will be unwieldy. And moving three attached poles in unison, especially with more than one child pitching in to operate each pole, can be challenging. But that's part of the idea. How can a group of people lift something too heavy for one person? How do you animate something too complicated for just one puppeteer? The answers and solutions make a powerful statement about group process. (Take care to choose a clear, level area for children to learn to work with the puppet. Children will need adult help, at least at first.) Each of the little projects you have chosen to do will come together in performance. And Abiyoyo makes for a complicated performance. Finishing the props draws each child into his role. Acting out the story together helps experiment with the dynamics of group performance and scripts.

You might invite families or other groups from your program to join you for one or two special performances, either in the classroom or in a communal space. These performances can be informal and flexible. A teacher reads the script, perhaps with one or two page turners. Several actors may play the boy and his father, so be prepared for frequent interruptions and repeated passages. The arrival of Abiyoyo will create an intense reaction: children will show how powerful an impression Abiyoyo has made on them.

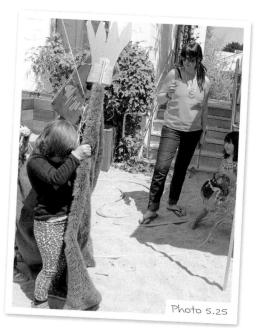

Photo 5.25

The Volcano Project: Incorporating Science and the Outdoors

PROJECT

The Volcano Project, developed by The Little School cofounder and longtime toddler teacher Tim Treadway, is a favorite early plaster exploration that combines the basic principles of short, evolving sequences; connections to dramatic play and imaginative themes; science exploration; and the outdoors. It also provokes thinking about mirror images, positive and negative space, and geometry.

The making of the volcano in this project is a preprogrammed, teacher-led process. Unlike the other projects in this book, this phase can't allow for child initiative or variation. And plaster is too volatile a medium for children to explore on a sensory level, at least when it is wet. I include the project here because it offers other avenues for inquiry and exploration:

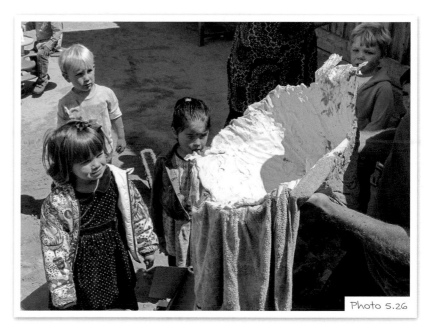

Photo 5.26

- It uses the outdoors, where many older toddlers are most engaged and enthusiastic.

- It provides a bridge from outdoor to indoor curriculum, between physical and intellectual exploration.

- It uses natural settings and materials.

- It focuses on a science concept that inspires children's thinking.

- It incorporates physical and natural science into the construction.

- It involves children in an apprentice role for a sophisticated and fascinating process of model making.

- The finished product, rather than the process of making it, becomes the source of exploration and inquiry.

WHAT YOU WILL NEED

- a five- or ten-gallon bucket
- eight to ten cups of dry casting plaster
- water
- cheesecloth
- a small cone
- disposable bath or beach towels
- spray oil (optional)
- tempera paint and glue (optional)

This project can also be inspired by and begin with research. Volcanoes, like skeletons or tyrannosaurs, seem to hold children in a special grip of mystery and danger. Many children, volcano lovers and otherwise, prefer to dig in the sand rather than visit the art table. Both these groups can be recruited to help plan, organize, and stage this project, as it features heavy labor and adult materials.

Consider beginning the research phase of the project in the classroom sensory table. Here, sand, water, dirt, clay, or other combinations of ingredients often inspire children to start building volcanoes of their own. (This is a perfect example of what Reggio calls a *Big Idea*).

When you see children constructing volcanoes spontaneously, you know it is time to do the Volcano Project. Since the making of the plaster volcano will not offer the children direct exploration, it is most effective to do it as a step in a larger inquiry into volcanoes. That way, the children will have chances to work on the sensory and physical aspects of construction, and the teacher-made plaster volcano can help address nature or construction questions that the children have generated on their own.

HOW IT WORKS

Dig a hole in the sand or dirt in your outside area that is the shape of an upside-down volcano—wide at the top and narrow at the bottom. Make sure the sand or dirt is wet. Place the cone in the hole to make an indentation in the top of the volcano. This will become the volcano's crater.

Soak the towels with water and something slippery like sunscreen or spray oil if you want. Line the hole with the towels, slippery side up. Use the towels to make contours of peaks and valleys. (Remember, it will come out in reverse—if you want something to stick out the side of the volcano, you must make an impression. If you want to make a crevice or stream, fold a length of the towel so that it sticks up.)

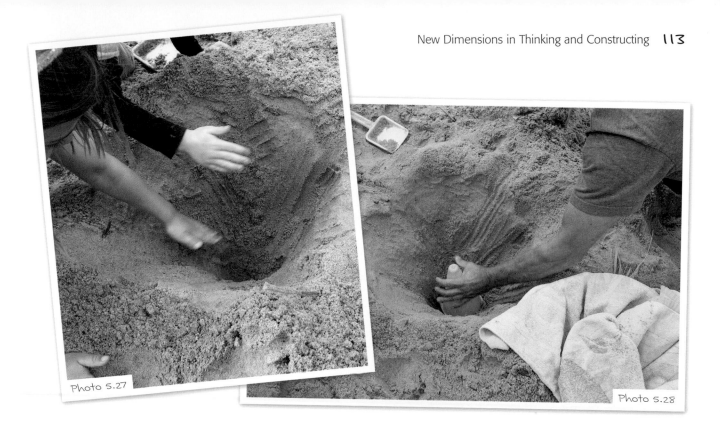

Photo 5.27

Photo 5.28

Mix the plaster carefully. Plaster dust is harmful to breathe, so be careful around the children; you may want to wear a mask. Be sure that, if any children are present for this phase, they stand at least ten feet upwind of the plaster as you pour it. Fill the bucket with about four gallons of water. Gently pour about four cups of powdered plaster at a time into the center of the bucket until it forms a small island of dry powder in the center of the water. Let the mixture sit for about five minutes.

At this point it is safe for children to come close, but it is not advisable for them to handle the wet plaster. Pour half of the plaster into the center of the hole, directly onto the towel. (You do not need to mix it in the bucket before pouring it in.) Spread the plaster as evenly as possible over the surface of the towel to make an upside-down, inside-out volcano shape. Cover the wet plaster with half the cheesecloth, pressing it down evenly and gently.

Pour the remaining plaster over the cheesecloth and distribute it carefully to evenly cover the surface without disrupting the form. The plaster will thicken quickly. You will have about ten minutes to apply both layers and spread them around. The finished volcano should be about one and a half inches thick, and it will harden in as little as one hour.

This first part of the project is ideal for older children working with a teacher. They can set up barriers around the hardening volcano and make signs to help the toddlers stay back—a little sand notwithstanding. (In other words, you can create an exploration for the children who are only watching this part!)

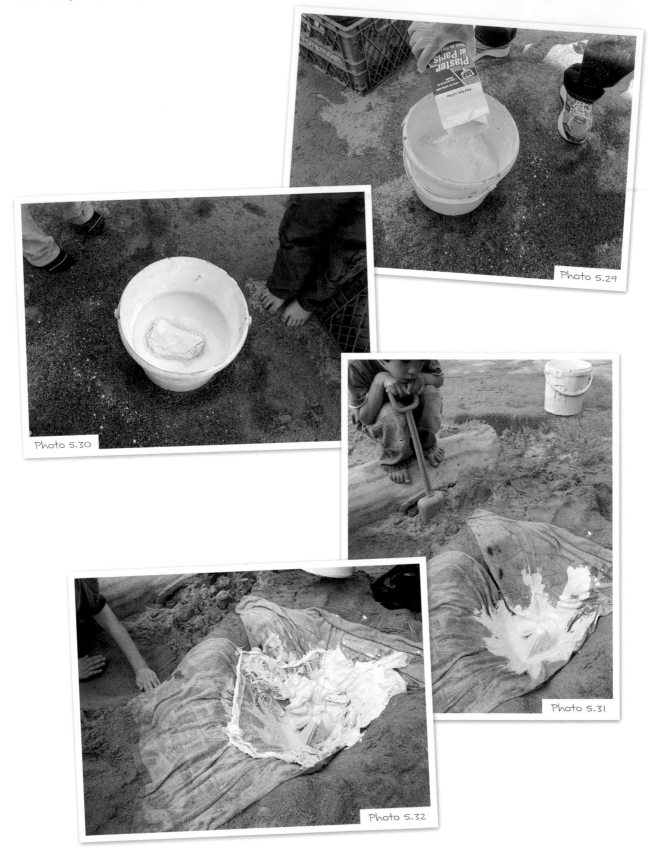

Photo 5.29

Photo 5.30

Photo 5.31

Photo 5.32

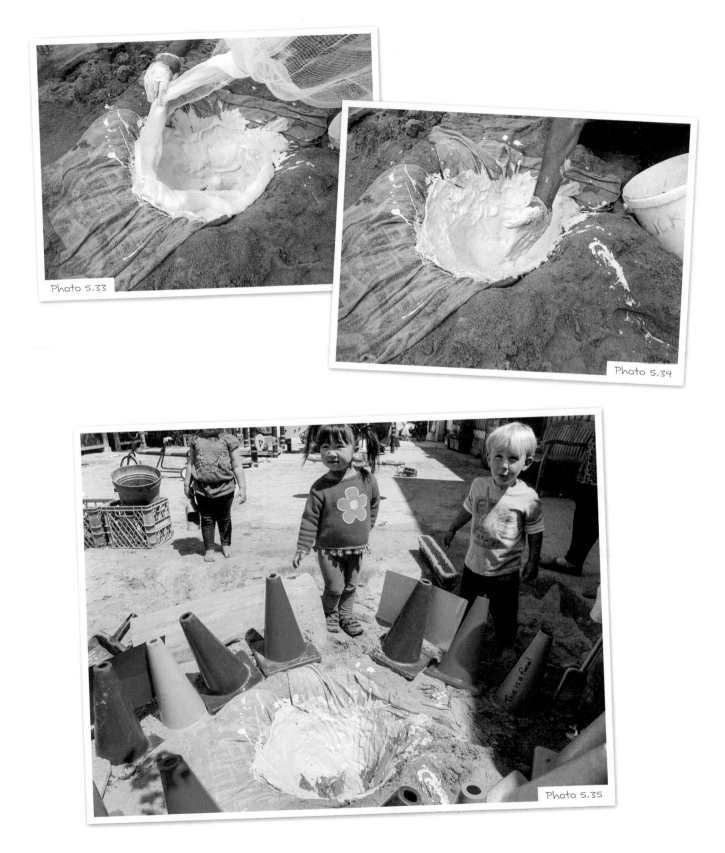

Photo 5.33

Photo 5.34

Photo 5.35

Remove the volcano, which will still be attached to the towel, from the hole, and brush off any excess sand or dirt. At this point, return the project to the children by helping them carefully but firmly pull off the towel. Although the molded plaster is hardened, this is really the beginning of the third and most important phase of the project.

The volcano can now be used for a variety of child-directed sensory and imaginative inquiry. Children often like to use it right away in the sandbox. It lends itself perfectly to children's curiosity about water, as they experiment with the best ways to make it erupt or dig water tunnels around or under it.

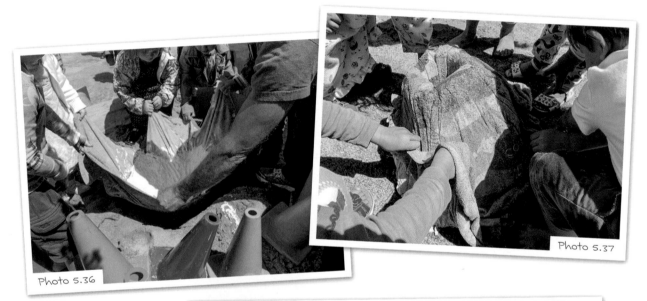

Photo 5.36

Photo 5.37

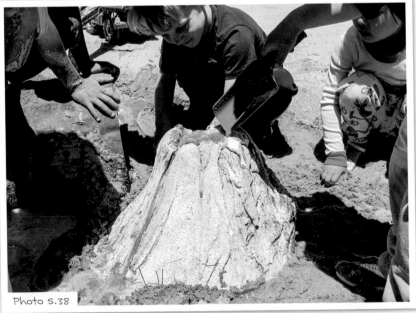

Photo 5.38

Bringing the volcano inside is another important step. Most toys and materials are designed to be either inside or outside toys. Yard play—getting dirty, running, shouting, playing sports—is seen by children and adults alike as a different kind of learning from classroom work. Many children nearing age four are aware that they love the yard more than the classroom, or vice versa. So the finished volcano opens up an inquiry into how these two modes of exploration can overlap and complement each other.

You can invite the children to deepen their exploration of the volcano in many different ways:

- Tempera paint mixed with glue will transform the plain white background into a lava-bright or earthy nature scape. As with all the previous projects, think carefully about color combinations.

- Dirt, moss, sand, or even real plants and flowers can be glued to the surface. You can mix dirt, grass seed, and glue on the surface. The children can then use spray bottles to keep it moist. The seeds will sprout and cover the volcano with real grass!

- The volcano can become a regular piece of equipment for your sensory table. It can be used with sand and water for sensory-based play. The crater can be used for lava experiments, such as the classic eruption involving vinegar and baking soda. The base can be used to explore volume and water physics. (Young children often turn the volcano over and use it as a bucket.) But it can also be the source of dramatic play.

The Batman Project: Exploring Character and Anatomy

PROJECT

Children in the latter stages of toddlerhood begin to identify themselves as members of their gender group. They tend to play with other boys or girls and often, though not always, gravitate toward materials, activities, and games that their same-sex peers play. It is a stereotype of this age that boys will be playing superhero and sports and girls will be playing princess and dancing ballet. But, on the other hand, we often see just that.

Of course, some boys are drawn to the more cerebral and emotional quality of girls' typical dramatic play. And many girls show interest in the power, conflict, and active physical expression that most boys bring to their play. Boys and girls alike set about mastering common challenges such as the monkey bars.

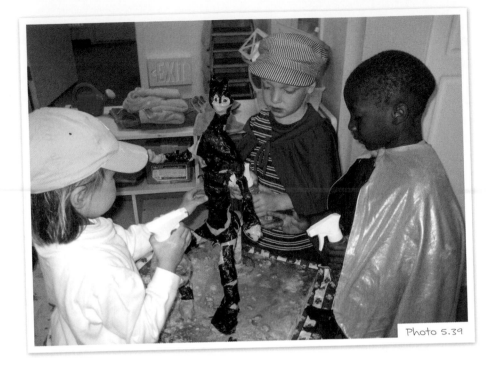

Photo 5.39

What we don't often notice as we look for connections in parallel play prefer-
ences is that all children are inclined to focus on simple core themes of play. For
boys, this is typically the act of play fighting. Put on the *Star Wars* theme music,
set up some ground rules for using paper light sabers the children have rolled up,
and many children will be happy for hours—inadvertent punches and bumped
heads notwithstanding.

Girls, on the other hand, may plan and negotiate costumes and roles forever,
while collecting piles of props to set the stage. In both cases we see that young
preschoolers are still searching for some of the basic sequencing, narrative, and
project management capacities that provide such a key role in group play.

In other words, learning how to play and pretend is a process of small inquiries
that help build the skills for larger, more complex inquiries. The sequence, cause
and effect, and resolution of a story form the backbone of play just as they do
for an art project.

So rather than thinking about children's social dynamics just from the stand-
point of adult cultural and social values, you can see dramatic play as an oppor-
tunity to help children develop their habits of learning. This kind of play involves
a series of cognitive, physical, social, and emotional challenges that can be mas-
tered through creative, collaborative curriculum. You can help children explore
their desire for social mastery through problem solving and symbolically through
pretending. You can address it as well by supporting the children as they work
together to create something inspiring.

The sequence of an art exploration lends itself well to defining and sequencing emotional mastery. The Batman Project applies an art inquiry sequence to some of the questions and challenges of gender roles and popular folklore. In particular, it aims to use the construction of a three-dimensional figure to bring different kinds of pretenders and players together. It encourages children to explore themes that typically inspire active movement and whole-body expression in a reflective, fine-motor environment. Finally, it promotes equality and richness of peer connections by pairing up small and large groups to collaborate in new ways.

Children can use an ever-expanding platform of stories, strategies, costumes, settings, and roles to keep their play moving. As Piaget suggested (1971a), children can and should construct their own play and learning. Nevertheless, Vygotsky's idea (1978) of mediating exploration to scaffold children's development is also valuable. Notice how much more comfortable and curious (not to mention focused and determined) children tend to be when adults provide boundaries and structure for their initiative: a balance of structure and freedom.

In particular, as dramatic play takes center stage in a group, children and teachers often negotiate

- how loud a classroom can be,

- how fast children can move,

- what kind of play and movement will happen in what spaces, and

- who can make what kinds of overtures to whom.

Children—not to mention teachers—who prefer more quiet, focused, or delicate experiences typically feel overwhelmed by louder, more kinesthetic children, and a classroom culture of frustration and disapproval toward rowdy play is not uncommon. How a class defines and negotiates these basic questions forms the initial research for the project. In other words, this is a good project to have in mind as a response to loud and chaotic times in your classroom.

This project can also help children develop tools to balance their wants and needs. One way or another, it regulates challenging play styles by treating them as worthy of curiosity, interest, and group attention. The foundation of this project, then, is an exploration of heroes, heroism, and character and how those translate to regulation, fair play, and citizenship.

Each group of children seems to settle on a set of characters from both folklore (knights, princesses) and popular lore (*Star Wars*, Disney princesses, television and movie characters). Begin this project by observing what characters and scenarios seem to come up with the children over time.

As Diane Levin and Nancy Carlsson-Paige (2006), among others, have documented, adults have numerous concerns about the effect of predefined fantasy

on children's imaginations. Commercial fantasy characters are connected to aggressive product marketing, to the point that children's characters are nowadays created to sell products rather than the other way around. Boys and girls are seen as separate markets, so characters are marketed to each gender based on different (and stereotyped) sets of values.

Coming from the image-driven and stimulation-oriented world of TV and computer games, the narratives and lore of media characters like Batman are seen as lacking in healthy emotional or moral messages; motivation, character, and conflict and resolution are not treated with sensitivity. Rather than promoting a child's own imagination and initiative, commercial fantasies seem to limit children's imaginations and connect them to themes and values many people don't embrace.

I do not mean to challenge any of these concerns. I share them as a teacher and parent. I support child care providers in whatever policy or approaches— even a complete ban on media characters and content—they use to keep children thinking and pretending on their own. I have tried many different approaches and policies myself over the last two decades.

As I've tried to limit the presence or prominence of commercial folklore and characters in my classroom, I've discovered how hard it is to simultaneously support children's initiative and disapprove of their favorite fantasies. I noticed that children were inclined to take fantasy play that grown-ups didn't like "underground" and revel in its forbidden status. (The strategic, even sneaky, ways that children naturally learn to get around adults is a sure sign of toddlerhood's end!) I also noticed that, where Batman and Barbie were concerned, I wasn't using the classroom the way I usually do: as a laboratory to help the children extend and deepen their understanding of topics that captured their interest.

You can do this project with any character—from literature, history, or current events, or even straight out of someone's head. It offers a great way to take back media folklore and connect it to the kind of expansive, collaborative inquiry described elsewhere in this book. This project can also support a classroom that doesn't wish to engage with what children are absorbing from electronic media.

In the case of The Little School, Batman was a source of interest and curiosity for many children, but also a lightning rod for disagreement over who was playing what, and with many of the issues mentioned above. But as we developed curriculum around Batman, each child and family found much to research.

Who is Batman? Is he good or bad? Would we be relieved or scared if we saw him at night? Many adults have considered and reconsidered these questions, raising another question: Is Batman a children's character or an adult's? These mysterious contradictions are not uncommon in mythology. They reflect a child's conflicted (or at least under-construction) view of self.

The School Club: Recognizing Different Learning Styles

Some children are more attuned to following their internal compass and creating their own exploration, while others are more responsive to structure and outside guidance or goals. On this subject, I am always reminded of the School Club. A few years ago, I was examining a tree branch with a very verbal and organized three-year-old whom I'll call Mason. The branch was covered with acorns that a woodpecker had embedded in tidy holes.

"Who put those acorns in there?" Mason asked.

"Ah," I said, "what a good question. Who put those acorns in there?"

"Just tell me the answer!" he snapped back with a hasty wave of his hand.

It happened that Mason had been complaining for a few weeks that school was boring.

"This is a baby school," he would say. "I'm ready for kindergarten!"

Based on Mason's desire for answers, we set up some traditional skill-based, workbook-type activities at the writing table to see how they appealed to him. We told the children that since they were so big, we would be starting a School Club, with tricky, big-kid activities. We stocked the area with copies of line drawings with partially finished faces and bodies, along with sorting and counting activities.

The results surprised us. When an activity called for a child to finish the face, Mason would add all the features, ears, a hat with a logo, a mustache, and a body. He was now the expert!

A full two-thirds of the class responded with similar zeal to the School Club. We discovered that many of our children had fine-motor and symbolic skills we hadn't recognized. And being able to stretch themselves and emulate the older children they admired did wonders for their learning and thinking in general.

We incorporated this newfound insight into our group's style and strengths throughout the curriculum—including art. And we saw that getting to a finished work with clear landmarks along the way is useful to at least some children as they become more sophisticated.

WHAT YOU WILL NEED

- ceramic clay
- a wire or wood armature (see the description on the next page)
- clay-working tools, craft sticks, rollers, and other tools for creating shapes or texture
- small containers for water
- spray bottles
- a sturdy plastic cover and space to store the work in progress
- fabric, tissue paper, buttons, beads, or other collage materials
- scissors
- possibly glue or staples

HOW IT WORKS

This project uses basic modeling techniques to bring a heroic character to life. In the process, children explore their relationship with media and popular folklore and the relationships among media, play, social connections, and narrative.

Start with exploring Batman in a series of modes, particularly comic strips, since they integrate art and language and they freeze the action in a way that promotes reflection and dialogue while still moving the story forward.

You will then move to clay and other modeling materials to go from open-ended exploration to finished work. This project uses clay to help expand the ways children explore images and works that are already well defined. It also shows children how they can manipulate and even alter popular imagery in an effort to understand it.

Wire or wooden armatures, which provide a skeleton or framework for modeling human figures, promote an element of character and anatomy study that is well-suited for close examination of themes that are often assumed or glossed over in active dramatic play. As children work together to build a character from the inside out, different emerging skills can be explored together. Physically and cognitively, children use their fine-motor skills, observation skills, and knowledge of the body and how it moves and functions. They also use their understanding of social and emotional interactions to explore aspects of power, morality, motivation, and persona.

This project invites active engagement, helping kinesthetic learners explore on a smaller scale. It also integrates the kinds of interests active players often explore—aggression, power, conflict, good and evil—with some of the characteristics of other kinds of players—scientific knowledge, aesthetic sensitivity, cultural literacy, storytelling.

The sequence of steps in this project is particularly flexible and adaptable. The key is to choose a theme that emerges from play among the children in your care. Beyond that, it is simply a process of teachers and children working together to build a character out of clay using a sturdy but malleable skeleton.

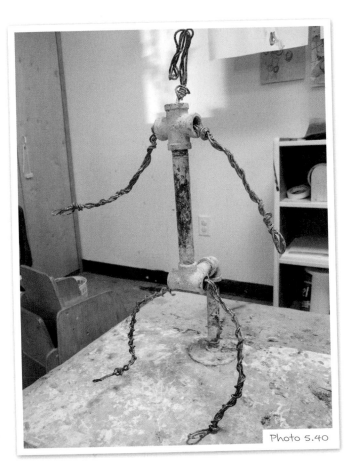

Photo 5.40

This project can be part of longer and broader explorations of clay. In fact, it works best if the children have done many explorations of texture and structure with clay before starting this project. That way, they will recognize the possible uses of clay, tools for cutting clay, water, and the armature just by seeing them laid out. You may wish to model softening the clay and putting it onto the wire skeleton in small pieces, but children will often figure out the technique without a lot of prompting or guidance. Spray bottles can draw children into the project and keep the clay from drying too quickly.

The armature provides a natural structure for assembling small parts into a whole that is more than the sum of its parts. But in the early assembly stages, we often see individuals, pairs, or small groups of children focusing on one part of the body.

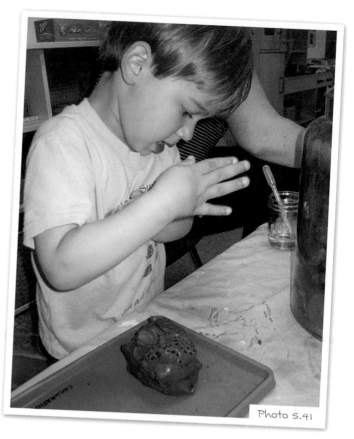

Photo 5.41

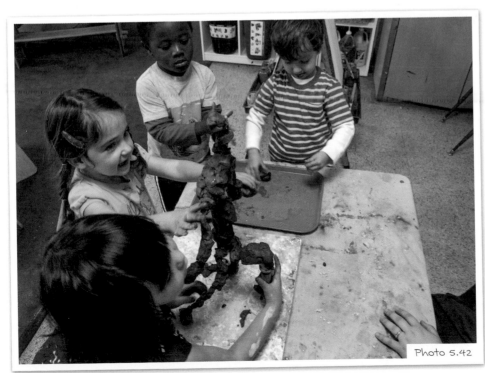

Photo 5.42

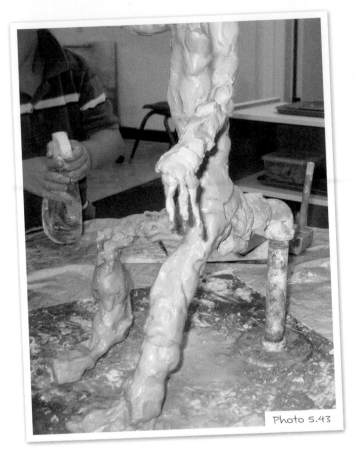

Photo 5.43

Some will spend time trying to make fingers and hands—rolling the clay into different thicknesses and working to join fingers to the ends of the arms. Others will focus on the feet. Many will be drawn to the face and head. Discussions of how the features should be represented in terms of shapes and structure as well as emotion and character stretch the children's abstract-thinking skills into the academic realm.

The challenge of maintaining the proper conditions for working with clay over time also adds opportunities for learning. The clay must be kept moist, so water and spray bottles play an important role, as do some kind of covering and a storage space. But covering delicate work will inevitably lead to some damage or change. This is part and parcel of the project. The fragility of the work increases children's investment in caretaking and moving it forward and inspires nurturing feelings for a figure of power.

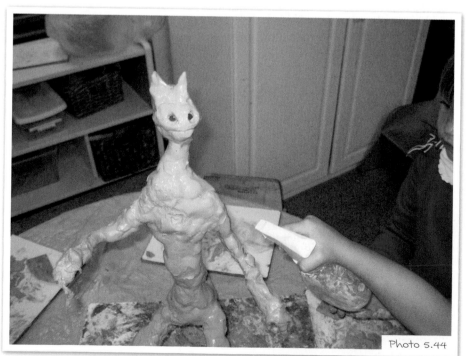

Photo 5.44

Most of the early figures children build on an armature have exaggerated skinny trunks and massive heads, arms, and limbs. This gives the group a wonderful chance to combine thinking about their image of a character and how to keep adjusting their work to express it. Along with that, they explore the physical sciences in clay projects: they try to create a structure that is balanced enough to hold itself up. A quick look at anatomy books or illustrations can support this stage.

As children explore deeper to re-create an image, they almost always move on from creating the body to adorning it with some kind of suit. Here you'll want to return to comic books and other research. Girls often recognize this part of the project as one that mobilizes their expertise, and they tend to take center stage in the costume design and construction. Many boys, however, will be invested in the collaboration and the project at this point, and they may find themselves drawn into dialogues about cape fabric and color.

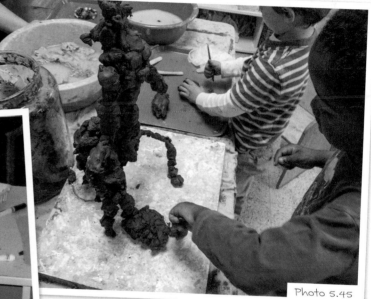

Photo 5.45

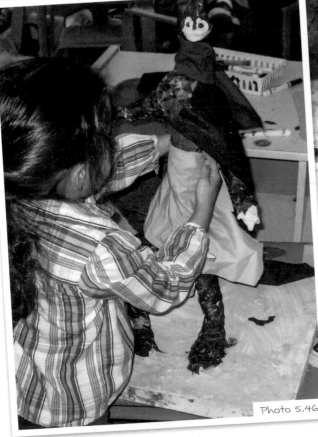

Photo 5.46

You can use open-ended dialogue with the children to explore questions about what materials and tools to use in creating a costume. Fabric scraps (especially sturdy fabric such as felt), tissue paper, beads, collage pieces, colored sand, or even paint can work well. Children will often demand real fabric, which creates wonderful challenges for how to attach it to the clay—embed it, glue it, staple or pin it, wrap it and attach it to itself. Again, false starts and structural failures are expected and are loaded with potential.

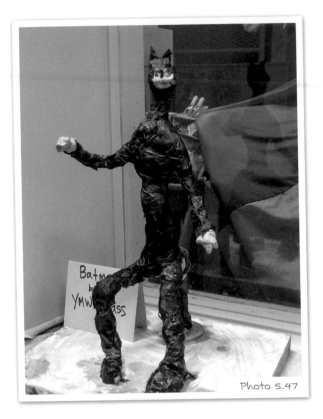

Photo 5.47

In a similar vein, making detailed choices about how to represent a common cultural image helps children experiment with their emerging cognitive flexibility. One reason young children are drawn to cultural icons like Batman is the fact that they address fundamental human themes but are well defined. Inviting children to play with and alter a clearly defined image helps them learn to generate their own imaginative ideas.

At this stage of the project you can hold a forum for discussing character that not only acknowledges the themes of children's fantasy but also plays with changing or expanding it. As children discuss how to construct Batman's belt, Ariel's tail, or Darth Vader's helmet, many differing ideas will emerge. Questions about whether the group has to use the same color, texture, shape, or size of a costume or body part inevitably come up.

This can also lead to an exploration of character and motivation—themes that drive children's interest in fantasy in the first place. Ageliki Nicolopoulou and Elizabeth Richner (2007), among others, have documented how children's exploration of good and bad characters, role reversal, and motivation plays a crucial role in the construction of both a sense of self and an understanding that others have thoughts and motives. Reconstructing character from the ground up and thinking about the choices or actions that may have gone into the character's development give children a chance to look at a familiar character through different lenses.

At The Little School, while working on constructing our Batman, these questions have come up:

- Where did Batman get his suit?
- Does it get dirty?

- Does he go to the bathroom?
- What's on his belt? What are they for?
- Why did he make his helmet like that?
- Why does he wear tights?

And some children have asked even deeper questions:

- Is Batman happy or angry?
- What does he want?
- Why does he fight the bad guys?
- What do they want?

By the time children have become accustomed to art projects like those in this chapter, we hope to see project-based learning happening all around the classroom—in science, literacy, math, and physical expression.

CHAPTER SUMMARY

This chapter explored three-dimensional projects that challenge children to expand their understanding of representational art. The projects also explored the advancing connection between art, cognition, and social interaction. Children learned to use art to express their fears and their own identities. In the Lion Head and Abiyoyo projects children explored the link between symbolic play, drawing, and writing. In my Conclusion, I look at creativity in the greater society.

Creativity and the Child's Role in the Community

As I close up this expanded tool box for supporting preschoolers, I'd like to offer a few ideas about how creativity functions in the school years and beyond.

CHILDHOOD AS PORTFOLIO BUILDING

It seems we ask children to be good at everything these days. They have to be creative and accomplished, socially competent and confident, athletic and academically involved, and independently organized and motivated.

The last five years have seen a widespread reconsideration of the reasons and effects of childhood as portfolio building (Levine 2006; Pope 2003). We have begun to reexamine *vertical* value in education—curriculum that is focused on preparing for the future—versus *horizontal* value—curriculum that offers diverse ways of exploring in the moment. Childhood, many argue, is a life in itself. Each stage, including the early years, offers its own qualitatively unique learning opportunities. The push to accomplish in order to open doors for the future can be a taxing and demoralizing experience for some children. It can discourage curiosity and inquiry.

In this context, creativity can be seen as another asset in a child's portfolio for future success. Playing music, dancing, painting, or working with clay becomes another box on a checklist of scheduled enrichment, the results of which can be filed away in time for another future-building experience. The sequence of

Photo 6.1

adult-organized activities becomes the model of living and learning, rather than the sequence of observation, reflection, and exploration that comes from within.

Perhaps this phenomenon can be seen most prominently on tours of private schools, where each program is touted as the best model for producing "twenty-first-century citizens." Of course, spirituality and creativity are often included in this vision of a super-rounded adult for changing times. But the emphasis on the future—the return on the investment—is still central.

This is a deliberately dark portrait of what is a much more finely shaded life for children, families, and schools. I include it for the sake of showing the contrast between horizontal and vertical value. Educators throughout the public and private school systems appreciate and work brilliantly with the ideas discussed throughout this book. I don't advocate that families exclude themselves from the culture around them. I shepherded two children through years of art, sports, and science activities without regret.

But contrast this adult-directed, future-based approach to the "image of the child" that emerges from the Project Approach or Reggio Emilia. Here, childhood is seen as a time of value in and of itself, and children are viewed as both innately competent and creative, as well as open to inspiration and ideas from others. Slowing down the moment to build learning and living habits, both trusting and guiding children's initiative, redefines "twenty-first-century citizens" as those who are creating and contributing right now. Young children are citizens of the world already.

This discussion raises key questions: Why should children be creative? What purpose does creativity serve now and for the future? What role does it or should it play in a child's development or emerging role in the community?

CREATIVITY AND THE IMAGE OF THE ARTIST

Before we take a closer look at our image of children, what is our image of creativity and artists? Over the course of human history, art has played many changing roles in ever-changing communities and societies. The modern image of the artist reflects a modern, individualist society—an individual who, through talent and training (and charisma), can create exceptional things and find exceptional success and acclaim.

Creativity and artistry have also become associated with pushing boundaries, and the image of the artist with emotional fragility, sensitivity, and rebellion. Charlie Parker, Jackson Pollock, Sylvia Plath, and Jean-Michel Basquiat are just a few examples of the groundbreaking yet "doomed" or "tortured" artist whose legend touches us all.

Creativity is indeed tied to temperament. Many of the most passionately artistic children have focused on that mode of self-expression because it feels safer and more comfortable than others. And the sensitivity and emotional openness that characterize many brilliant artists can make for a volatile relationship with the world.

It is safe to say that most families and educators do not have this kind of outcome in mind when they seek to foster children's creativity. But where is the model for the kind of artist we *do* have in mind? Where are the artists who are also positive players in their communities, the ones who are emotionally balanced, athletic, social, and financially successful? Does our culture in fact support a high degree of creative expression alongside cultural and professional competence?

We cannot view children's creativity as an all-consuming, exclusive definer of personality, nor can we simply add it to the pile of skills and accomplishments in a child's college portfolio. Creativity for children is a means of development, one that can become part of a child's outlook on life and learning. It is also, as Reggio Emilia and the Project Approach remind us, what makes us human: the ability to represent experience and express ideas, to symbolize and organize.

Project-based curriculum sees creative expression not just as a fundamental mode of learning and exploring but also as a model for organizing the projects of life itself. Systems of representing, expressing, and communicating are the primary foundations of education and society—of civilization itself.

Project-based models also remind us that we do not need to "promote" creativity in children. Creativity—unique and divergent ways of exploring and thinking—is innate to human development. Our role as adults is to recognize, acknowledge, and respond to children's own internal ability to create. A creative

stance toward children and early childhood education must be built on a view of children as innately creative and competent.

If we step back from the popular images of the tortured artist, we can start to see creativity all around us. We may not see painters, musicians, or sculptors. We may in fact see scientists, entrepreneurs, educators, and business people. We would most certainly see people who are rewarded for finding pragmatic uses for their creativity, be it copy writing or environmental engineering. We would see people who can synthesize different ideas or fields or solutions, as Daniel Pink describes in *A Whole New Mind* (2005).

Everywhere in our society of free thinkers, we see people who have developed a creative disposition toward life: those who have gained enough knowledge and confidence in their own style of exploration and sufficient joy and curiosity in life to make creative choices about jobs, relationships, and even their roles in the community.

American culture forms a unique kaleidoscope of world cultures, old or foreign values and practices, and new or synthesized ones (Rogoff 2003). We must use the art and lore of each cultural thread to understand ourselves and each other and to help children learn to weave threads of identity and experience into a new fabric of shared values.

The goal of fostering children's creativity, then, is not to define the artist's place in the community, nor to build a more perfectly rounded citizen of the future, nor to offer refuge to those who struggle with their place in a community. It is to support their attempts to find their place in the world.

The projects presented in this book offer a few ideas for putting creativity into action by drawing curriculum ideas from what is known about child development and what you observe about children's thinking and learning, and by using expression and representation to enhance learning and development in general. The final aim is to foster confidence and creativity in children as they engage with community and society both as children and for the rest of their lives.

Suggested Reading

Bodrova, Elena, and Deborah J. Leong. 2007. *Tools of the Mind: The Vygotskyian Approach to Early Childhood Education*. 2nd ed. Upper Saddle River, NJ: Pearson/Merrill Prentice Hall.

Bronfenbrenner, Urie. 1979. *The Ecology of Human Development: Experiments by Nature and Design*. Cambridge, MA: Harvard University Press.

Carini, Patricia F. 2000. "A Letter to Teachers and Parents on Some Ways of Looking at Reflecting on Children." In *From Another Angle: Children's Strengths and School Standards*, edited by Margaret Himley and Patricia F. Carini, 56–64. New York: Teachers College Press.

———. 2001. *Starting Strong: A Different Look at Children, Schools, and Standards*. New York: Teachers College Press.

Chard, Sylvia C., and Yvonne Kogan. 2009. *From My Side: Being a Child*. Lewisville, NC: Gryphon House.

Corsaro, William A. 2003. *"We're Friends, Right?": Inside Kids' Culture*. Washington, DC: Joseph Henry Press.

Edwards, Carolyn, Lella Gandini, and George Forman. 1998. "Introduction: Background and Starting Points." In *The Hundred Languages of Children: The Reggio Emilia Approach—Advanced Reflections*, 2nd ed. edited by Carolyn Edwards, Lella Gandini, and George Forman, 5–26. Greenwich, CT: Ablex Publishing.

Ehlert, Lois. 1991. *Red Leaf, Yellow Leaf*. San Diego: Harcourt Brace Jovanovich.

Emberley, Ed. 1992. *Go Away, Big Green Monster!* Boston: Little, Brown.

Galdone, Paul. 1979. *The Three Billy Goats Gruff*. New York: Clarion Books.

Gandini, Lella, Lynn Hill, Louise Cadwell, and Charles Schwall. 2005. *In the Spirit of the Studio: Learning from the Atelier of Reggio Emilia*. New York: Teachers College Press.

Greenspan, Stanley I., and Serena Wieder, with Robin Simons. 1998. *The Child with Special Needs: Encouraging Intellectual and Emotional Growth*. Reading, MA: Perseus Books.

Hallowell, Edward M. 2002. *The Childhood Roots of Adult Happiness: Five Steps to Help Kids Create and Sustain Lifelong Joy*. New York: Ballantine.

Jarrell, Randall, and Nancy Ekholm Burkert. 1972. *Snow-White and the Seven Dwarfs: A Tale from the Brothers Grimm*. New York: Farrar Straus Giroux.

Jones, Elizabeth, and Gretchen Reynolds. 1992. *The Play's the Thing: Teachers' Roles in Children's Play*. New York: Teachers College Press.

Katz, Lilian. 1998. "What Can We Learn from Reggio Emilia?" In *The Hundred Languages of Children: The Reggio Emilia Approach—Advanced Reflections*, 2nd ed., edited by Carolyn Edwards, Lella Gandini, and George Forman, 27–48. Greenwich, CT: Ablex Publishing.

Keyser, Janis. 2006. *From Parents to Partners: Building a Family-Centered Early Childhood Program*. St. Paul: Redleaf Press.

Lewin-Benham, Ann. 2010. *Infants and Toddlers at Work: Using Reggio-Inspired Materials to Support Brain Development*. New York: Teachers College Press.

Maass, Robert. 1992. *When Autumn Comes*. New York: Henry Holt.

Pelo, Ann. 2007. *The Language of Art: Inquiry-Based Studio Practices in Early Childhood Settings*. St. Paul: Redleaf Press.

Risom, Ole, and Richard Scarry. 1963. *I Am a Bunny*. New York: Golden Press.

Robinson, Ken. 2001. *Out of Our Minds: Learning to Be Creative*. Oxford: Capstone Publishing.

Rockwell, Anne, and Lizzy Rockwell. 1989. *Apples and Pumpkins*. New York: Aladdin.

Roffman, Leslie, and Todd Wanerman with Cassandra Britton. 2011. *Including One, Including All: A Guide to Relationship-Based Early Childhood Inclusion*. St. Paul: Redleaf Press.

Shaw, Charles G. (1947) 1988. *It Looked Like Spilt Milk*. New York: Scholastic Books.

Siegel, Daniel J. 1999. *The Developing Mind: How Relationships and the Brain Interact to Shape Who We Are*. New York: Guilford Press.

Silverman, Erica, and S. D. Schindler. 1995. *Big Pumpkin*. New York: Aladdin.

Titherington, Jeanne. 1986. *Pumpkin, Pumpkin*. New York: Greenwillow Books.

Topal, Cathy W., and Lella Gandini. 1999. *Beautiful Stuff! Learning with Found Materials*. Worcester, MA: Davis Publications.

Walsh, Ellen Stoll. 1995. *Mouse Paint*. New York: Sandpiper.

Williamson, G. Gordon, and Marie E. Anzalone. 2001. *Sensory Integration and Self-Regulation in Infants and Toddlers: Helping Very Young Children Interact with Their Environment*. Washington, DC: Zero to Three Press.

References

Ayres, A. Jean. 1979. *Sensory Integration and the Child.* Los Angeles: Western Psychological Services.

Bos, Bev. 1978. *Don't Move the Muffin Tins: A Hands-Off Guide to Art for the Young Child.* Carmichael, CA: Burton Gallery.

Bowlby, John. (1969) 1982. *Attachment.* Vol. 1 of *Attachment and Loss.* New York: Basic Books.

Brown, Margaret Wise. 1958. *The Color Kittens: A Child's First Book about Colors.* New York: Golden Press.

Bruner, J. S. 1981. "Intention in the Structure of Action and Interaction." In *Advances in Infancy Research,* vol. 1, edited by Lewis Paeff Lipsitt and Carolyn K. Rovee-Collier, 41–56. Norwood, NJ: Ablex Publishing.

Case, Robbie. 1985. *Intellectual Development: Birth to Adulthood.* Orlando: Academic Press.

Dewey, John. 1916. *Democracy in Education.* New York: Macmillan.

Duckworth, Eleanor. 2006. *"The Having of Wonderful Ideas" and Other Essays on Teaching and Learning.* 3rd ed. New York: Teachers College Press.

Edwards, Carolyn P., and Debbie LeeKeenan. 1992. "Using the Project Approach with Toddlers." *Young Children* 47 (4): 31–35.

Ehlert, Lois. 1991. *Red Leaf, Yellow Leaf.* San Diego: Harcourt Brace Jovanovich.

Emberley, Ed. 1992. *Go Away, Big Green Monster!* Boston: Little, Brown.

Erikson, Erik H. 1963. *Childhood and Society.* 2nd ed., rev. and enl. New York: Norton.

Flavell, John H., Patricia H. Miller, and Scott A. Miller. 2001. *Cognitive Development.* 4th ed. Upper Saddle River, NJ: Prentice Hall.

Freud, Sigmund. 1949. *The Ego and the Id.* London: Hogarth Press.

Gerber, Magda. 1991. *The RIE Manual for Parents and Professionals.* Silver Lake, CA: RIE Publications.

Honig, Alice S. 2006. "Babies Boost Skills by Taking Advantage of Rhythm and Rhyme." *Early Childhood Today* 21 (2): 18.

Kantor, Rebecca, and K. L. Whaley. 1998. "Existing Frameworks and New Ideas from Our Reggio Emilia Experience: Learning at a Lab School with Two- to Four-Year-Old Children." In *The Hundred Languages of Children: The Reggio Emilia Approach—Advanced Reflections,* 2nd ed., edited by Carolyn Edwards, Lella Gandini, and George Forman, 313–34. Greenwich, CT: Ablex Publishing.

Katz, Lilian G., and Sylvia C. Chard. 2000. *Engaging Children's Minds: The Project Approach.* 2nd ed. Stamford, CT: Ablex Publishing.

Levin, Diane E., and Nancy Carlsson-Paige. 2006. *The War Play Dilemma: What Every Parent and Teacher Needs to Know.* 2nd ed. New York: Teachers College Press.

Levine, Madeline. 2006. *The Price of Privilege: How Parental Pressure and Material Advantage Are Creating a Generation of Disconnected and Unhappy Kids.* New York: HarperCollins.

Lieberman, Alicia F. 1993. *The Emotional Life of the Toddler.* New York: The Free Press.

Maass, Robert. 1992. *When Autumn Comes.* New York: Henry Holt.

MacLean, Paul D. 1990. *The Triune Brain in Evolution: Role in Paleocerebral Functions.* New York: Plenum Press.

Malaguzzi, Loris. 1998. "History, Ideas, and Basic Philosophy: An Interview with Lella Gandini." In *The Hundred Languages of Children: The Reggio Emilia Approach—Advanced Reflections,* 2nd ed., edited by Carolyn Edwards, Lella Gandini, and George Forman, 49–98. Greenwich, CT: Ablex Publishing.

Mangione, Peter L., J. Ronald Lally, and Sheila M. Singer. 1990. *The Ages of Infancy: Caring for Young, Mobile and Older Infants.* Video. Sacramento, CA: California Department of Education.

Meltzoff, Andrew N. 2003. "Imitation as a Mechanism of Social Cognition: Origins of Empathy, Theory of Mind, and the Representation of Action." In *Blackwell Handbook of Childhood Cognitive Development,* edited by Usha Goswami, 6–25. Malden, MA: Blackwell Publishers.

Montessori, Maria. 1967. *The Absorbent Mind.* Translated by Claude A. Claremont. New York: Holt, Rinehart and Winston.

Musatti, Tullia, and Susanna Mayer. 2001. "Knowing and Learning in an Educational Context: A Study of the Infant-Toddler Centers of the City of Pistoia." In *Bambini: The Italian Approach to Infant/Toddler Care,* edited by Lella Gandini and Carolyn Pope Edwards, 167–80. New York: Teachers College Press.

Nelsen, Jane, Lynn Lott, and H. Stephen Glenn. 2000. *Positive Discipline in the Classroom: Developing Mutual Respect, Cooperation, and Responsibility in Your Classroom.* Rev. 3rd ed. Roseville, CA: Prima.

Nicolopoulou, Ageliki, and Elizabeth S. Richner. 2007. "From Actors to Agents to Persons: The Development of Character Representation in Young Children's Narratives." *Child Development* 78 (2): 412–29.

Perry, Bruce D., and Maia Szalavitz. 2006. *The Boy Who Was Raised as a Dog and Other Stories from a Child Psychiatrist's Notebook: What Traumatized Children Can Teach Us about Loss, Love, and Healing.* New York: Basic Books.

Piaget, Jean. 1959. *The Language and Thought of the Child.* Translated by Marjorie and Ruth Gabain. 3rd rev. and enl. ed. London: Routledge and Kegan Paul.

———. 1971a. *The Construction of Reality in the Child.* Translated by Margaret Cook. New York: Ballantine.

———. 1971b. "The Theory of Stages in Cognitive Development." In *Measurement and Piaget.* Proceedings of the Conference on Ordinal Scales of Cognitive Development, edited by Donald Ross Green, Marguerite P. Ford, and George B. Flamer, 1–11. New York: McGraw-Hill.

Pink, Daniel H. 2005. *A Whole New Mind: Why Right-Brainers Will Rule the Future.* New York: Riverhead Books.

Pope, Denise Clark. 2003. *"Doing School": How We Are Creating a Generation of Stressed Out, Materialistic, and Miseducated Students*. New Haven, CT: Yale University Press.

Risom, Ole, and Richard Scarry. 1963. *I Am a Bunny*. New York: Golden Press.

Rockwell, Anne, and Lizzy Rockwell. 1989. *Apples and Pumpkins*. New York: Aladdin.

Roffman, Leslie, and Todd Wanerman, with Cassandra Britton. 2011. *Including One, Including All: A Guide to Relationship-Based Early Childhood Inclusion*. St. Paul: Redleaf Press.

Rogoff, Barbara. 2003. *The Cultural Nature of Human Development*. New York: Oxford University Press.

Seeger, Pete. 1986. *Abiyoyo*. New York: Simon and Schuster.

Shaw, Charles G. (1947) 1988. *It Looked Like Spilt Milk*. New York: Scholastic Books.

Silverman, Erica, and S. D. Schindler. 1995. *Big Pumpkin*. New York: Aladdin.

Titherington, Jeanne. 1986. *Pumpkin, Pumpkin*. New York: Greenwillow Books.

Vygotsky, Lev S. 1978. *Mind in Society: The Development of Higher Psychological Processes*. Edited by Michael Cole et al. Cambridge, MA: Harvard University Press.

Walsh, Ellen Stoll. 1995. *Mouse Paint*. New York: Sandpiper.

Wanerman, Todd. 2009. "Using Story Drama with Young Preschoolers." In *Here's the Story: Using Narrative to Promote Young Children's Language and Literacy Learning*, edited by Daniel R. Meier, 27–38. New York: Teachers College Press.

Waters, Kate, and Madeline Slovenz-Low. 1990. *Lion Dancer: Ernie Wan's Chinese New Year*. New York: Scholastic.

Wolfe, Tom. 1981. *From Bauhaus to Our House*. New York: Farrar Straus Giroux.

Index